BRIGHTON PUBS

DAVID MUGGLETON

AMBERLEY

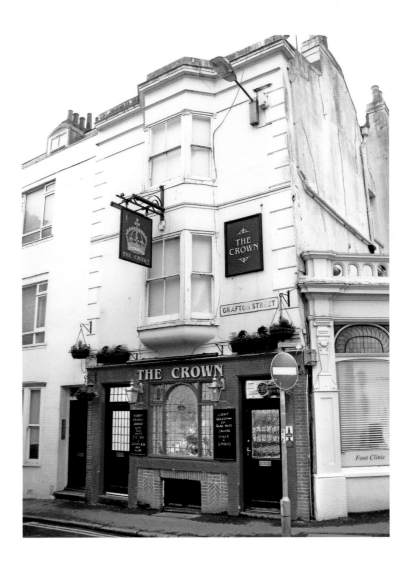

First published 2016

Amberley Publishing
The Hill, Stroud
Gloucestershire, GL5 4EP

www.amberley-books.com

Copyright © David Muggleton, 2016
Maps contain Ordnance Survey data.
Crown Copyright and database right, 2016

The right of David Muggleton to be identified as
the Author of this work has been asserted in
accordance with the Copyrights, Designs and
Patents Act 1988.

ISBN: 978 1 4456 4993 1 (print)
ISBN: 978 1 4456 4994 8 (ebook)

British Library Cataloguing in Publication Data.
A catalogue record for this book is available from
the British Library.

Typesetting by Amberley Publishing.
Printed in the UK.

Contents

Foreword

At Brighton, I think it was, that a society was formed for the Suppression of Virtue
Thomas De Quincey

My love affair with Brighton began in reality in October 1985 when I moved there from my native Leicester to become a mature student at the University of Sussex. Over thirty years later, the romance continues undiminished, on my part at least, although I sense my attentions are still reciprocated. We no longer live together, it is true – yet we did so on no less than three separate occasions and I still pay regular homage. Perhaps one day we will be permanently reunited, yet I doubt it – for she (and Brighton, being the Queen of Watering Places, is definitely a 'she') has acquired expensive tastes. I had first visited her only through the imaginative powers of Graham Greene and Patrick Hamilton (Hassocks-born, Hove-resident Hamilton – now there's a writer, if ever I knew one, who understood pubs intimately, and unfortunately died an alcoholic, but that's another story). Literary representations could not prepare me for the experience of first walking down Queen's Road from the railway station to my boarding house in a stuccoed Regency Terrace. Or alighting from a coach at Pool Valley to catch my first dazzling glimpse of the Palace Pier. Or hearing the sound I am now habituated to but which was entirely absent from landlocked Leicester – screeching seagulls.

I was previously familiar from personal acquaintance with most of the pubs that found their way into this book, but during the course of my research I have come to feel a curious and intimate connection with characters who died decades before I was born, in some cases before my grandparents were born. This has mostly been a happy union and if supplied with a Tardis I would love to time travel to shake hands with Tom Bovey, Percy Morel, Tubby Edlin and Alf Appleton and give a big pat to Peggy the dog. On other occasions however, this author has felt like a voyeur in other people's tragedies. I can only hope that I have not been too intrusive. As to the choice of pubs, I can imagine some readers shaking their heads in disbelief while muttering to themselves 'What!? No Battle of Trafalgar? No Bath Arms? Why no Gloucester – that big hotel owned by the Edlin family, now the North Laine brewhouse? And why is there nothing at all in the Ditchling Road area, etc, etc?' All I can say in my defence is

that the word limit restricted me to just forty-five pubs. I began with a shortlist of ten more than that final number but, in the manner of a football manager whittling down his talented but oversized squad for the competition proper, had to ruthlessly discard otherwise eminently qualified candidates.

And what were those qualifications? First and most obviously, that the pubs had to be in some or all of the following ways notable or historic – by architecture (heritage interiors or Grade-II listed buildings), by events (happy or tragic, although it says something about human nature that the latter were by far the most prevalent) or by people (landlords or customers, either famous or murderous as it turns out). Second, that they were all still open to visit, although given the current rate of pub closures the best guarantee I can give is that they were trading at the time of delivering the manuscript to the publishers. The third qualification is that they needed to fit into a series of walks. This proved the deciding factor for the ten eventually left out, for two opposing reasons: most fell in areas already oversubscribed, a few others were isolated outliers. If there is ever a sequel, *More Brighton Pubs*, I will kiss and make up with those ten pubs. In the meantime enjoy the forty-five that made it.

David Muggleton
Bognor Regis, 13 December 2015

A NOTE ON HISTORICAL SOURCES

Although I had intended to provide in-text citations or references as evidence for all the claims made in each and every paragraph, I came to feel that such a style would prove intrusive in a book that is meant to be as entertaining as it is informative. For those who were familiar with my Sussex pub fanzine, *The Quaffer*, this book reads like one big Quaffer – but with pictures. All photographs were taken by me except for where credit is otherwise acknowledged. Given also that most sources drawn upon in its construction were individual archival documents, I took the decision not to list these in their entirety but to provide only a summary and a select bibliography. If any reader wishes to know the precise source of any claim made here, I will happily provide it. I have attempted to check the credibility of all claims made either anecdotally or found in secondary sources, but in a few cases this has not proved possible. The first volume of records that would have established when nearly all the pubs in this book initially received their license were unfortunately too damaged to be consulted. I have instead used a pub's first appearance in street directories, themselves not wholly reliable sources of evidence. Any errors that remain in the final text are, of course, my own.

Introduction

Brighton: Old Ocean's Bauble

Edmund W. Gilbert

The origins of Brighton lie in a small Saxon settlement known as Beorhthelm's Tun, which translates as the Farm of Beorhthelm. Its centre was on a ridge once known as the Knab, now called Brighton Place and site of the Druids Head pub. The people would have brewed their own ale, sweet, unhopped, flavoured with herbs and spices and consumed in simple alehouses. A division between farming and fishing communities had occurred by at least the Norman Conquest, but in medieval times the latter had developed into a significant industry. After a charter was granted by Edward II in 1313 to what was by then called Brighthelmstone, or one of the many variants of that spelling, buyers and sellers plied their wares at fairs and markets and the town began to prosper. A large area called the Hempshares was set aside for the fishermen to grow the hemp from which their ropes and twine were made. In 1580 there were 400 able mariners who outnumbered the land men by nearly four to one. By 1829 there were still 300 fishermen. The old inns were then concentrated around gaps from the beach and in the neighbourhood of the old fish market. Many were used almost exclusively by fishermen. Indeed, it was their custom to gather at the Greyhound (now the Fishbowl) near the bottom of East Street to auction their daily catch.

The Greyhound had previously gone by the nautical name of the Anchor. It is the city's only surviving pub that can claim a documented link back to the 1600s, which in Brighton is as old as it gets. Other existing pubs have stated an earlier date of establishment: the Cricketers, the Seven Stars and the Druids Head have all at some point made a case for the 1500s. The evidence for all these claims is circumstantial at best and must in any case refer to previous houses on the site. That the medieval town, largely of wood and thatch construction, was torched by French raiders in 1514 is less in dispute than the extent to which it was destroyed. Many foreshore dwellings were also lost to two great storms of the early 1700s and by constant coastal erosion, by which time the population had fallen by a third. Whatever the causes, architectural historians are firm in their judgement that Brighton does not have domestic or

commercial buildings with fabric surviving from the sixteenth century or earlier. What is retained from the medieval period is the grid layout of the old town, with the coast bounded by West Street, North Street and East Street. The pubs we shall visit on our walk of that area, now known as The Lanes, were mostly licensed by the late 1700s, by which time the town had a new-found prosperity.

In 1800 the town had forty-one inns – one for every thirty houses and 178 residents. By 1831, the number of inns had more than doubled to eighty-nine but the population had increased over five-and-a-half fold to 40,634. Brighton, as it was officially known from 1810, had been transformed from a fishing community in decline to a pleasure ground for the famous and the fashionable. One attraction was seawater, or rather the growing belief in its supposed health-giving properties. In 1750 Dr Richard Russell, of nearby Lewes, published his *Dissertation on the Use of Sea Water in the Diseases of the Glands*. It was originally in Latin and obviously aimed at learned society. Seawater bathhouses, Awsiter's, Brill's and Mahomed's, soon sprang up in the town. Although long since demolished, their presence lives on in the names of two pubs in The Lanes: the Pump House and the Bath Arms. Another reason for the turnabout in the town's fortunes was the Royal patronage of the Prince of Wales, later King George IV. Enormously popular in Brighton, 'Prinny' brought with him the libertine culture of excessiveness that characterises the city to this very day. It became necessary to both accommodate and amuse the influx of visitors and the Georgian inns fulfilled this function admirably. One of the largest hostelries was the Old Ship, still standing on the seafront and which gave its name to Ship Street. It then had seventy beds, stabling for 100 horses, plus a coffee room and wine vaults.

By 1851 Brighton had 65,569 residents and over 200 licensed premises. The town had become less attractive to fashionable society and lost its Royal patronage in 1845. What fundamentally changed its character was the coming of the railway, with the symbolic arrival of the first train from London on 21 September 1841. In the decade before the opening of the line, the population of the town increased by 15 per cent; the increase the decade after was 41 per cent. This growth consisted of a new, more democratic set of social classes – professionals, clerks, artisans, servants, shopkeepers and the second- or third-class day tripper. The railway was also directly responsible for new purpose-built hotels just outside the terminus, the Railway (now the Grand Central) and the Prince Albert. It equally encouraged a proliferation of plebeian pubs, many of which originated as basic beer retailers licensed under the 1830 Wellington Act. Trafalgar Street once had eleven pubs plus three unnamed beerhouses. The railway also bought a halt to the days of the old coaching inns, although some, notably the Royal Oak in St James's Street, survived as hotels. In March 1892 Brighton had 572 hotels, public houses and beerhouses for a population of 115,400. The greatest concentration was in the poorer areas: Edward Street had twenty-six pubs. Yet the number had peaked and continuous contraction was to follow.

Some sections of Victorian society exhibited a strong moralistic streak that exhorted abstinence from the demon drink. Temperance organisations proved to be adept at political lobbying, with successive legislation being passed to curtail opening hours. Magistrates were also given more power to refuse the renewal of licenses and the

number of pubs subsequently decreased. Faced with fewer outlets, the common brewers began securing their market share of tied houses by purchasing more of them to rebuild in majestic and opulent style. The additional capital required for such a venture was raised through flotation on the stock market. The bubble burst in 1899, but not before it gave rise to what has been called the golden age of pub building. This is how Tamplins, Brighton's biggest brewery, came to make expensive alterations to many of its pubs in the late 1890s, particularly to those it purchased from the West Street Brewery following a further share issue. Individual proprietors also turned to local architects to redesign their pubs in sumptuous style, with majestic mahogany bars, cut and etched glass and sweeping island counters. The Seven Stars in Ship Street, the Lion in St James's Street and the Quadrant in North Street Quadrant were all altered in such fashion in this final decade of the nineteenth century.

A phenomenon of the 1920s and 1930s was the improved public house, based on a philosophy of 'fewer, bigger, better'. There was to be no return however to Victorian flamboyance: solid Brewers' Tudor and elegant neo-Georgian were among the preferred styles. The latter was taken up by the Kemp Town Brewery, whereas the Portsmouth and Brighton United Breweries favoured the use of green faience tiling. Both these local breweries were evangelists for the improved public house. In this period they rebuilt or newly built sixty-nine and forty-nine pubs, respectively (27 per cent and 17 per cent of their tied-house stock). Four examples from each brewery are visited in this book. The movement for modernised pubs was motivated by a reformist zeal that was forward-looking and progressive. The intention was to do away with disreputable 'drink-shops' that had few amenities and no ancillary activities to discourage perpendicular drinking by a predominantly male clientele. The improved pub aimed to promote cultural respectability by appealing to a wider class base and creating a comfortable environment welcoming to women and families. A Ladies' Parlour and a Children's Room were, for instance, provided in the mock-Tudor King & Queen, Marlborough Place, rebuilt 1931–36 by Clayton & Black.

If the 1930s were reforming then the 1960s were futuristic. Under the banner of 'slum clearance', tower blocks replaced traditional terraces. Whole swathes of Brighton streets with their corner pubs were lost to the wrecking ball, particularly to the north-east from Edward Street and west of London Road. Others were demolished for the construction of the Churchill Square shopping centre. Existing pubs also underwent changes. In a relatively affluent society less concerned with traditional class distinctions, the internal compartmentalisation of pubs into separate Public, Private and Saloon Bars appeared increasingly anachronistic. Both the King & Queen and the Golden Fleece (now the Market Inn) had their three bars knocked into one at the end of the 1960s. The décor altered, too. The industry came to be dominated by a handful of big national brewers: the 'choice' in Brighton was mostly between Charrington, Courage, Watneys or Whitbread. These created a corporate, branded identity for all their pubs, eroding their individuality. At the same time, young people had both income and leisure time at their disposal and were targeted by brewery marketing executives who thought mild beer and matchwood interiors to be hopelessly outmoded. Lager, keg bitter, Campari and Babycham became the order of the day. Wall-to-wall-carpeted

pubs with chromium, plastic and Formica fittings became the newfangled places to drink.

The past thirty years have seen something of a reversal of such trends. First, we have become concerned with conservation and heritage. In 1999, several Brighton pubs of architectural significance received Grade-II building listing protection or had amendments made to their listings. During the same period, the Campaign for Real Ale has identified local pubs with heritage interiors of national and regional importance. In 2015, the city council placed fourteen Brighton pubs on its new Local List of Heritage Assets. Second, we have emphasised the importance of locality. This is linked to the resurgence of real ale and the astonishing growth of microbreweries. Brighton had lost all its old local breweries to a process of acquisition by the 1960s. The city now boasts four micros that have opened in the last four years. Third, the industry has been deregulated. If this has led to pubs being owned mostly by non-brewing companies, then most of these Pubcos, such as Drink In Brighton stock locally-brewed beers. The market is also highly segmented, with bars, licensed cafés and gastro pubs all catering for different type of customers with variegated tastes. In many cases these drinking places inhabit imposing and historic buildings once used for other purposes, such as chapels, banks and newspaper offices. Brighton has certainly retained its Regency raffishness but has adapted to suit the changed conditions of the twenty-first century. It is hoped that the exhilarating diversity of this vibrant city will be reflected in the eclectic choice of pubs in this book.

Brighton Station and the North Laine

A comfortable inn in Brighton is better than a spunging-house in Chancery Lane
William Makepeace Thackeray

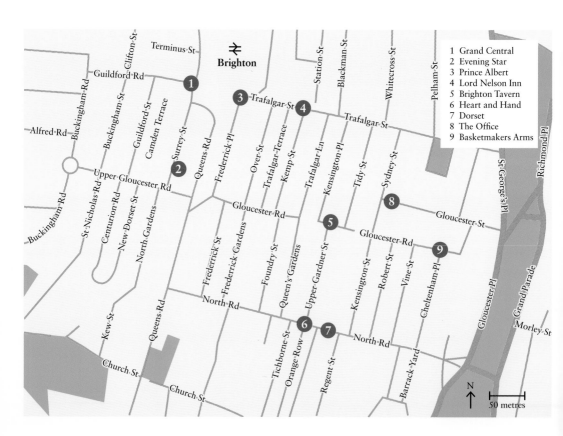

1 Grand Central
2 Evening Star
3 Prince Albert
4 Lord Nelson Inn
5 Brighton Tavern
6 Heart and Hand
7 Dorset
8 The Office
9 Basketmakers Arms

When seen on a Brighton street map, says Nigel Richardson in his psycho-geographical narrative, *Breakfast in Brighton: Adventures on the Edge of Britain*, the railway lines appear to sweep into the station like power cables carrying charge from London into a junction box. This is where we begin our journey, that black junction box that, to paraphrase Graham Green in *Brighton Rock*, continually disgorges visitors that flock down the pavement or rock down the Queen's Road on the top of trams (now buses) to the seafront. Except that we are not following that tourist route, past the Queens Head and the Royal Standard, the latter rebuilt in florid style in 1899 as a honeypot for the holidaymakers. We are going first to Surrey Street, a small terrace of early Victorian bow-fronted properties that used to house artisan workers. No. 56, now half of our second pub on this walk, the Evening Star, used to be a laundresses before it became a pub. The space with the bus stops between the station concourse and Surrey Street was not opened up until 1924, with further extensions in 1935. The demolition work to remove the buildings that used to stand here left our first pub, the Grand Central (originally the Railway Hotel), with the unofficial address of No. 1 Brighton. The Queens Head also used to claim that designation but has only its side wall visible.

We now dip down Trafalgar Street to visit the Prince Albert, built to take advantage of the arrival of the railway in 1841. As we pass under the railway bridge, see how the station building, designed in Italianate style by David Mocatte; extended 1882–83 by H. E. Wallis, was erected on a huge platform with vaults, these now occupied by Brighton Toy & Model Museum. This part of Brighton, bounded by Trafalgar Street and Church Street, is called the North Laine. Before its development in the nineteenth century, it was one of five open fields surrounding the old town of Brighthelmstone. The painting on the side of the Pond pub in Gloucester Road is probably an accurate artistic impression of how rural this area once was. The strip pattern of land division and ownership of these lanes (from the Anglo-Saxon for loan or lease) dictated the eventual grid system of the streets. To reach our fourth pub, the Lord Nelson, we pass Kemp Street, where in 1934 the body of Violette Kaye was secreted in a truck in a basement room. Although the case is referred to as one of the Brighton Trunk Murders, the killer, Toni Mancini, was found not guilty. We continue this compact walk moving directly south to take in the Brighton Tavern, Heart & Hand, and the Dorset, then back north to visit the Office and the Basketmakers Arms.

GRAND CENTRAL, NOS 29–30 SURREY STREET

Two recently installed clocks at these premises, one on the external east wall, the other inside in the pediment of the bar back, both say 'established 1920'. The time is wrong on two counts, for the Railway Hotel, as this pub was known for most of its existence – this is, after all, Brighton, not New York – is first listed in the 1839 directory under Charles Penfold, in anticipation of the arrival of the railway station, and was rebuilt by Tamplins Brewery in its present form in 1925. Until 1924 there was no immediate station access from Surrey Street to Queen's Road, but after the Terminus Hotel in Queen's Road, and the Terminus Shades in Surrey Street were demolished that year, the old Railway Hotel found itself for the first time in direct view from the station. The rebuilding of the premises was to take advantage of that lucky break to dominate the

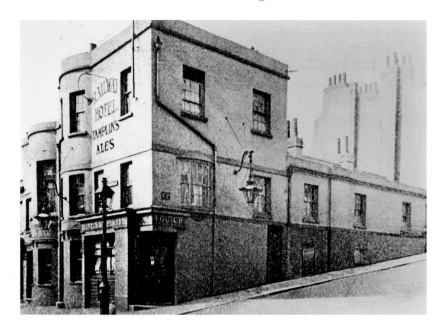

Railway Hotel in 1911 (courtesy of the James Gray Collection).

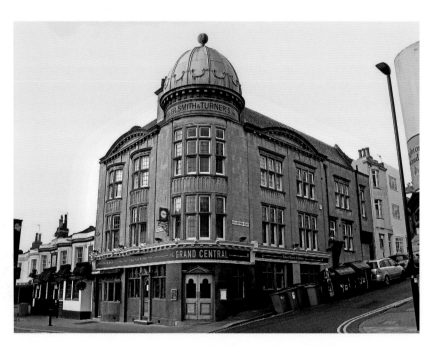

Railway Hotel, rebuilt in 1925, now the Grand Central.

vista and become the first building encountered in full-frontage by visitors. This is why it was subsequently known as the Railway Hotel No. 1.

Almost certainly designed by Arthur Packam, in-house architect for Tamplins, it is a suitably imposing building, three storeys in baroque style, Ashlar faced and with *that* copper dome atop the corner tower. Two disused pedimented entrances along the

Surrey Street elevation, one in a bowed frontage, designate old internal divisions into separate bars. In 1985 it was renamed the Nightingale and accommodated the theatre of that name on the first floor. In 1997 it was again renamed, this time as the Finnegan's Wake. In its latest incarnation as the Grand Central it was purchased in 2013 by Fuller's Brewery. Closed for a short period to be given a complete refurbishment, it reopened in spring 2015. The 1925 bar counter was removed to provide a modern interpretation of a high-Victorian servery, but the attractive coloured leaded glass of the same date in the west wall was incorporated into the redesign. The pub was placed in 2015 on Brighton and Hove City Council's Local List of Heritage Assets.

EVENING STAR, NOS 55–56 SURREY STREET

The Evening Star's renown as a real alehouse spreads far beyond Brighton, and the birth here of what would become the Dark Star Brewery is well documented, but few probably know of its history prior to 1994 when a micro plant was installed in the cellar. It first appears in the 1854 directory at No. 56 with Ann Scott as the licensee. By 1868 it had become conjoined with No. 55, fabricating its uneven double bow-fronted first floor. The internal load-bearing roof beam marks where it was two separate properties and the brick column just inside the front door was part of the dividing wall. The census of 1881 records a young Robert William Pitt as the licensee and head of family living here with his two sisters and his widowed mother. Robert will become the long-standing landlord of the Cricketers pub. The eldest of his sisters, barmaid Carrie, will become husband to Tom Bovey, landlord of the Quadrant, whose name still appears on that pub's fascia, but that is a topic of this book's final walk.

By 1911 the pub is home to Henry and Mary Hilton and the three-year-old twin sisters, Daisy and Violet Hilton-Skinner, conjoined at the pelvic area. Even at this

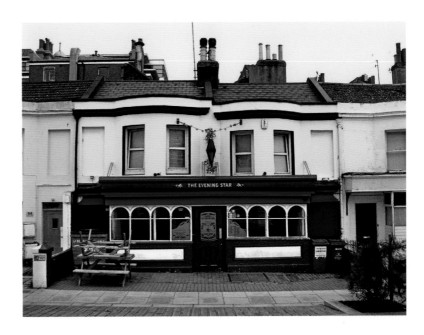

Evening Star, a conjoined pub.

Sarah and Alistair, not conjoined at the Evening Star.

tender age they were touring Britain as 'The United Twins'. They were born at Riley Road, Brighton, on 5 February 1908 to Kate Skinner, an unmarried domestic servant working at the Queens Arms, George Street, then ran by the Hiltons. Mary was the midwife who assisted at the birth. She adopted the twins and exhibited them in freak-sideshow fashion, first at the Queens Arms, then the Evening Star, exploiting them for her own gain. The twins were to forge a career in vaudeville in the United States under the management of Mary's daughter Edith who, with her husband Meyer Meyers, treated them even more cruelly than had Mary. The twins successfully sued the Meyers in 1931 and the following year featured in the Tom Browning cult horror movie *Freaks*, after which their star waned. They died alone in penury in their trailer home as North Carolina grocery store workers in 1969.

The Landlords

Robert William Pitt was born in Shoreham to George David Pitt, a pork butcher. His exact birth date is elusive, but he was baptised on 26 November 1854. The family was living in Fulking at the time of the 1871 census. A move to Brighton may have been precipitated by the death of Mr Pitt senior, but in 1881 Robert is landlord of the Evening Star in Surrey Street. His older brother, George Edward, is landlord of the Thatched House in Black Lion Street in 1883–85, by which time Robert is close by at the Cricketers. George is succeeded at the Thatched House by Tom Bovey, who in 1885 married Robert and George's sister Carrie. By 1891 Robert has two stepdaughters from his own marriage to Emily Renner. In 1899 Robert becomes the proprietor of the Lion Hotel in St James's Street. He is briefly joined there by his brother George who dies in 1900 aged forty-seven. The license of the Lion is afterwards held until

at least 1939 by both Robert and his nephew, George's son, Albert Edward. Robert will survive not only this nephew, who dies in 1944, but Albert's son, Albert George Edward, who dies in his early twenties. Robert carries on at the Cricketers until his death, aged ninety-two on 14 February 1947.

PRINCE ALBERT, NO. 48 TRAFALGAR STREET

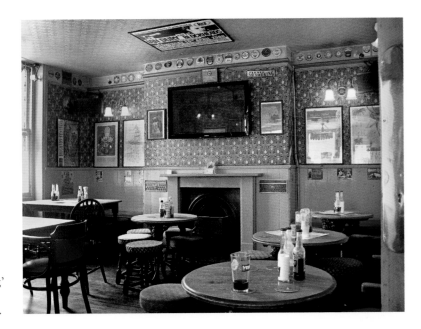

'Please No Smoking' at the Prince Albert old Smoking Room.

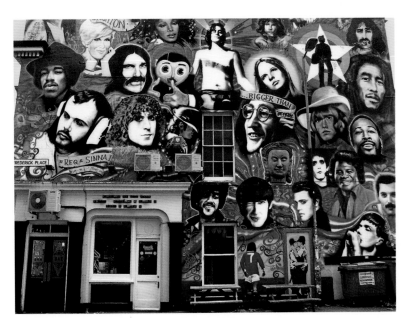

All-star cast at the Prince Albert.

This is a Grade-II listed building of imposing aspect: three storeys, the top recessed above a second floor entablature and a central bay carried by ionic pilasters. Originally constructed as a hotel in 1841 by the West Street Brewery in anticipation of arrivals from the new railway, its first directory appearance is of 1843. The year 1860 on the parapet presumably refers to a rebuilding. An 1881 alteration is the ground floor right-side window with rusticated pilasters and cornice, continuing around the corner. The right-hand flat arched portion on Frederick Place is a 1931 addition, as is the current bar counter. The interior retains a five-room layout that predates that period. A Public Bar at the front right was once partitioned from a Smoking Room on the left. The rear left was formerly a Coffee Room. The two rooms behind the servery were the Saloon Bar and Kitchen, respectively.

On 22 August 1934, the stage paper *The Star* carried a story headed 'A Very Good Dog is Peggy'. This referred to the twelve-month-old pet spaniel of the pub's landlord Alf Appleton, who had taught her to fetch and carry any named object in her mouth and to lay a whole table for lunch with all implements correctly placed. By 1937 Peggy's exploits had made her a canine star in two pictures, *The Magic Key* and *Trust Peggy*, predating Lassie by several years. A Pathe newsreel of 1944, now available online, shows Mr Appleton seated with friends in the Smoking Room of the pub while Peggy carries out various tasks, including fetching a mallet for her master, which he uses to break up a 'fight' at the bar between two quarrelsome customers.

From a trickster dog to two ghostly children – the reports are modern but the children may be Victorian. The sound of running up and down the stairs has been accompanied by childish giggling and laughter. The footsteps go into the upstairs function room, which is then found to be empty. A visiting psychic claimed that a boy and a girl were 'trapped' behind the old glass in the stairwell landing. A previous landlady and her elderly mother were alone in the pub in 1970 when the latter shouted 'get those children out. They're a damned nuisance'. Although the daughter could see no children her mother insisted that the boy was sitting quietly and behaving himself but that the girl kept running around the bar and hovering near her handbag! The haunted function room has since hosted music bands, hence the mural paintings of rock stars on the Frederick Place external wall, but note the Kissing Policemen by Banksy, just to the right of George Best.

The Landlords

Alf Appleton was born into a large family in Feltham, Middlesex, in March 1879. His father Reuben was a beerhouse-keeper. In 1901 Alf married Lucy Maud Charlotte Josling and had two children, Alfred Frank in 1904 and Leslie George in 1909. Alf became landlord of the Thurlow Hotel in Edward Street in 1927 before moving to the Prince Albert in 1933. Of the marvellous abilities of his trickster dog, Peggy, he modestly said, 'all dog owners could teach their pets to do the same providing they started when their dogs were quite young and treated them with every kindness.' Alf died aged sixty-nine on 29 July 1948. Lucy outlived him only until 7 April 1951. Their oldest son carried on the licence at the Prince Albert before moving to the nearby Hollybush. Younger son Leslie died aged fifty-four on 15 January 1963 as landlord of the Castle Inn, Clarence Gardens. See Alf and Peggy come alive before your eyes at http://www.britishpathe.com/video/dog-aka-peggy-the-dog/query/Brighton.

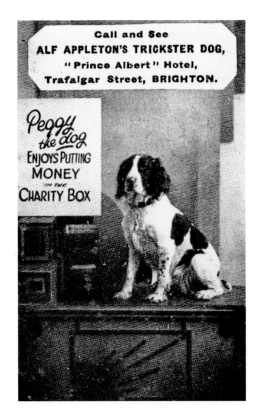

Peggy the trickster dog (courtesy of North Laine Community Association).

LORD NELSON INN, NO. 36 TRAFALGAR STREET

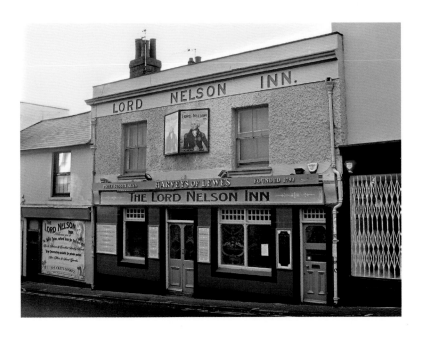

Lord Nelson Inn, blue hued.

The premises were first occupied in 1848 by beer retailer Thomas Edelston who bestowed the name Lord Nelson by 1854. The top storey, with its parapet, is Victorian but the tiled ground-floor frontage is interwar. The attractive etched windows – 'Smoking Room', 'Wines, Spirits' – each feature a pair of dolphins, the one-time brand and motif of the Kemp Town Brewery, acquired by Charrington in 1954. Harveys Brewery purchased the pub from them in 1980 and the following year installed a new bar at a lower level through the archway at the right. The conservatory beyond was created in 2000. The central entrance once had a vestibule, similar to that on the right but with a partition giving access to a Bottle & Jug. There is still a low dividing screen, but the top section was removed in 2014 and replaced by a small window. The two front areas, previously a public and a private bar, with their curved, indented panelled counter are contemporary with the tiled frontage, while the tiered bar back shelving could be older. This is a CAMRA pub of some regional heritage importance.

BRIGHTON TAVERN, NOS 99–100 GLOUCESTER ROAD

Beer retailer John Brown was operating in 1848 from what was then No. 100 Gloucester Lane. The pub name first appears in 1877 when William Pelling was the licensee. Its eventual owners, the Kemp Town Brewery, became evangelists for the cause of 'public house improvement' and in 1936/7 the premises were rebuilt and expanded to absorb the confectioners at No. 99. The shop area became a new Public Bar and what had hitherto been the Public Bar became a Private Bar. Both were entered through a newly built central lobby, which also gave access on the immediate left to a small Bottle & Jug. The pub was given a brick refronting in somewhat austere neo-Georgian style and has since suffered no more than the loss of its stepped parapet. It is a rare example of a modernised Kemp Town Brewery house not designed by J. L. Denman – the architect was F. W. Pearcy.

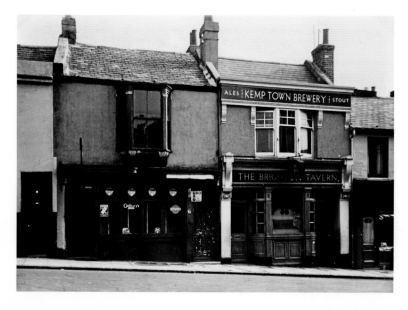

Brighton Tavern
before rebuilding
(courtesy of
the James Gray
Collection).

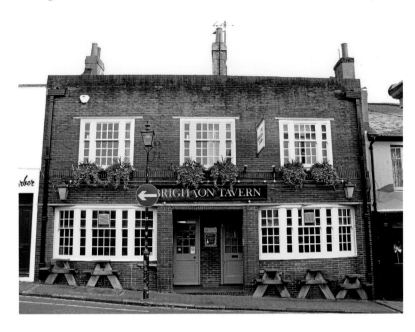

Brighton Tavern,
wonky 'T'.

Enough of the interwar interior work survives for CAMRA to consider the pub of
regional heritage importance. Of the two left-side doors in the central entrance, the
one still in use would have originally led to the Bottle & Jug: the seat has since been
removed and a replacement countertop inserted. The old Public Bar retains a good
brick fireplace, field-panelled dados and curved counter with tiered and fluted bar
back. The counter front in the old Private Bar is also original but its top and the basic
back shelving are post-war. The toilets at the rear have been modernised since this
author keeled over in the gents thirty years ago after starting the night on the home
brew. They now provide a passage from one bar to the other that was not previously
possible except via the ladies. The pub is popular with the LGBT (Lesbian, Gay,
Bisexual, Transgender) community.

HEART & HAND, NO. 75 NORTH ROAD

Built in 1854 as the Hand & Heart at what was then No. 85 North Lane, its name
was for some reason reversed thirty years later. It was an un-reconstituted Victorian,
stucco-walled, Rock Brewery house until a 1934 remodelling to characteristic design
by architect Stavers Hessell Tiltman for the Portsmouth and Brighton United Breweries.
The interior has since been opened up and completely altered, but the exterior work
remains intact with green-glazed tiling and a fine set of leaded stained-glass doors and
windows. At the west end of the North Road elevation, 'Bar' appears on a disused
door that was the site of a Bottle & Jug. What was the Saloon Bar at the east is marked
by 'United Ales' on a double window, 'H & H' on the corner double door, 'Heart &
Hand' on a double window, 'Saloon Bar' on another disused door, and 'United Ales' on
a single window. Replacement coloured glass appears in the window that once looked
out from an alcove seat at the north end. Now owned by Enterprise Inns, the Heart &

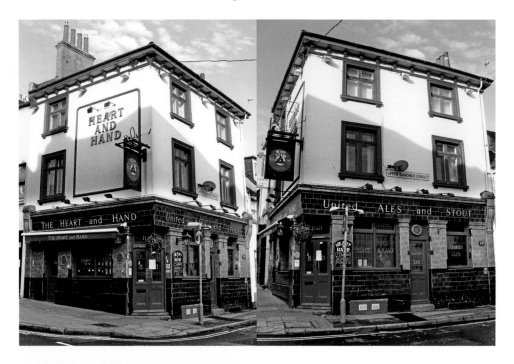

Above: Two elevations of the Heart & Hand.

Left: Rocking at the Heart & Hand.

Hand has been run by members of the same family for nigh on two decades. It is famed for its multi-genre jukebox with a playlist of punk, dub reggae, soul, sixties pop and psychedelia, Motown and rock 'n' roll. The pub was placed in 2015 on Brighton and Hove City Council's Local List of Heritage Assets.

DORSET, NO. 28 NORTH ROAD

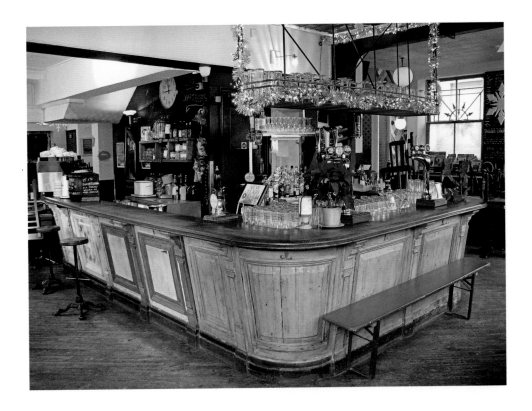

Above: Bar counter at the Dorset.

Right: Etched glass window at the Dorset.

This became the Dorset Arms in 1822 under licensee William Smith at what was then No. 28 Gardner Street. The three-storey corner site property with rusticated ground floor was completely rebuilt in its present form in 1870. It was once partitioned into a Private Bar, Public Bar and a central Bottle & Jug Department, as can be seen in the splendidly decorative set of etched glass doors and windows that survive from alterations of either 1897 or 1904. The ground floor bar boasts a fine raked counter of similar period with pilasters and console brackets. These surviving features make it a CAMRA pub of some regional heritage importance. In 1949 a number of internal partition walls were removed to form two large bars, a Public along North Road and a Saloon along Gardner Street. The counter was also set back and both ends extended: note the different top at the west and the close proximity at the south to the 1930s fireplace. The restaurant room along Gardner Street was brought into use from a separate property in 1995. The pub has long provided a meeting place for various groups. In the late 1920s, under licensees Herbert Henry and Katie Edwards, it hosted gatherings of the charitable organisation Ye Ancient Order of Froth Blowers. In the early 1980s, the Brighton Lesbian Group held socials here on Sundays and Wednesdays. Inquisitive regulars were told by landlady Irene Shields that the group were the 'Ladies Sports Club'! Having dropped the 'Arms' from its name in 1994, the Dorset now operates as continental-style café bar.

Ye Ancient Order of Froth Blowers

Also known as the A.O.F.B., this was a subscription-based organisation that used beer drinking as a bonhomous means of fundraising for deprived and invalid children. It also encouraged support for disabled or unemployed ex-servicemen. Describing itself as 'the cheeriest charity in the world', it was organised along a spoof Masonic lodge system with mock-serious enactments of rites and regalia. Branches, humouredly known as 'Vats', met regularly to 'gollop beer with zest' in commodious hotels, clubs, bars and pubs where fines were levied for misdemeanours such as forgetting to wear one's A.O.F.B. branded cufflinks. Progression through the ranks as a 'Blower', 'Blaster', 'Tornado' or 'Monsoon' was dependent on the number of people a member had recruited to the cause. Although high spirited, its largely male membership was socially respectable and the motto of the order was 'lubrication in moderation'. Founded in 1924 by ex-serviceman Mr Bert Temple, with eminent surgeon Sir Alfred Fripp, the A.O.F.B. raised an astonishing £100,000 within four years and had a worldwide membership of some 700,000 when formally dissolved in 1931.

THE OFFICE, NOS 8–9 SYDNEY STREET

This author drank here in the mid-1990s when it was the Green Dragon and an epicentre of Brighton's alternative scene. Some of the photographs he took of the pub's customers were later published in his book on style subcultures. He was not present however on the night of 10 May 1994 when charity worker Thomas Connor, aged thirty-three, was murdered in the toilets. Connor was discovered lying in a pool of blood and, despite the attention of paramedics, died soon after admission to the Sussex Royal County Hospital. His attacker, David Soar, had repeatedly stamped on Connor's head before robbing him of £20. Soar, also known as Mad Dog, had just been thrown

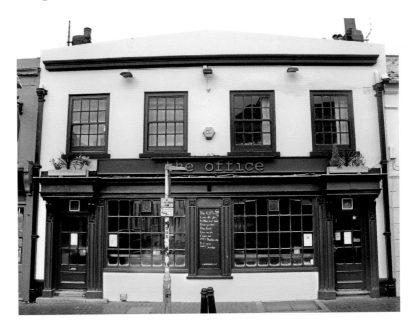

The Office, formerly the Green Dragon.

Georgie and Owen hard at work at the Office.

out of the nearby Prince George pub in Trafalgar Street after being involved in an argument with Punch and Judy Man, Sergeant Stone.

Beer retailer Edward Carter was operating here at No. 9 in 1845. Within three years he had given it the Green Dragon name it retained for over a century and a half. It became owned by Smithers Brewery until acquired by Tamplins in 1929. It subsequently passed to Courage Brewery, but even by 1968 it was still remembered

as a Smithers house, although whether with or without fondness for that brewery is a fact not recorded. In 1937/8 the pub was refitted and refronted to include what had been a separate, private dwelling at No. 8. Plans by Arthur Packham show the new premises consisting of a Saloon Bar on the left and Public Bar on the right. A passage behind the counter gave access to the toilets. The pub was rebranded under its current name in 1999, but retains the frontage and interior wall panelling from the pre-war remodelling, while the roof beam and supporting column mark the old room division.

BASKETMAKERS ARMS, NO. 12 GLOUCESTER ROAD

Landlord here for nigh on thirty years, Peter 'Blue' Dowd, has turned the Basketmakers into something of a Brighton institution, consummately catering for the tastes of a variety of customers and receiving numerous food and drink awards in the process. Yet the pub has had a chequered history. It was not always the civilised place it is now, although it is hard to imagine another of its long-serving landlords, Albert W. Harriott, host from the mid-1920s until the early 1950s and described as 'a clean-living, honest, upright character and totally unlike the publicans of his day', allowing his pub to become a roughhouse. The premises in his time consisted of a Public Bar along Gloucester Road, accessed by the corner entrance, and a Bar Parlour with its own door at Cheltenham Place. A small Private Bar between the two rooms was removed in 1931, its position now marked by the half window and jutting interior wall on the Cheltenham Place elevation.

Its story starts with Thomas Knight who, in 1852, moved into the property at what was then Gloucester Lane, remaining there until the mid-1870s. By 1855, he had added beer retailing as a sideline to basket and sieve-making. The following year he called the premises the Broker's Arms, possibly in respect to his neighbour William Giles, a furniture broker. Knight had reflected his own artisan business in the name

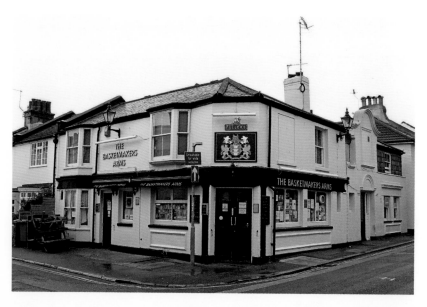

Basketmakers Arms, a Brighton institution.

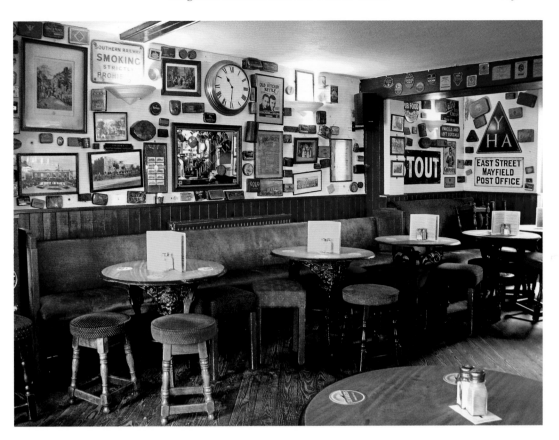

Old tins and things at the Basketmakers Arms.

by 1859. In addition to periods as a free house, the pub has been under the control of several breweries: both Tamplins and Kidd & Hotblack, reputedly; it was a Kemp Town Brewery house in the late 1940s, acquired by Charrington in 1954; it became Gale's by the late 1970s and since 2006 has been in the hands of present owners, Fuller's. There is a remarkable collection of antique paraphernalia displayed on the walls. Open the old tins to read obscure messages on scraps of paper left inside, and be sure to write one of your own for the next customer to occupy your seat.

Pub Room Terminology Explained

Public Bar: the most basic room for the plebeian customer where drinks were slightly cheaper.

Private Bar: implies a more intimate relationship by a group of regulars known to each other and the licensee.

Bar Parlour: a more select apartment with admittance perhaps even restricted to certain customers.

Saloon Bar: a more salubrious bar that attracted a higher status of customer, a forerunner of the Lounge.

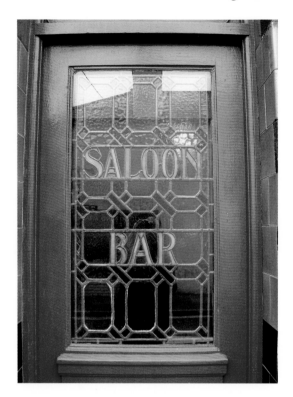

Leaded glass Saloon Bar window
(Heart & Hand).

Smoking Room: not the only room where smoking was allowed but one suggesting greater comfort and more leisured activity.

Bottle & Jug: also off-sales, a small area with a separate entrance where drink could be purchased for home consumption.

Cultural Quarter and the Lanes

The sweet smell of success ... it smells like Brighton and oyster bars and that kind of thing
Sir Laurence Oliver

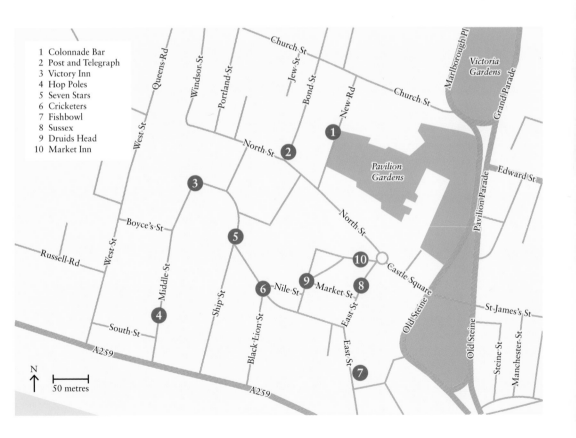

1 Colonnade Bar
2 Post and Telegraph
3 Victory Inn
4 Hop Poles
5 Seven Stars
6 Cricketers
7 Fishbowl
8 Sussex
9 Druids Head
10 Market Inn

We start this walk in the middle of Brighton's Cultural Quarter, at the Colonnade Bar attached to the Grade-II listed Theatre Royal. This is the third oldest surviving purpose-built theatre in England, with original fabric from 1807. It was refronted along with the Colonnade in 1894. The theatre has three other old bars, but for the exclusive use of paying audiences. Opposite at the north-east is the Brighton Dome, built 1804–08 by William Porden as the stables of the Royal Pavilion. Among other amenities, it now contains the corn exchange where the Sussex Branches of CAMRA hold their annual Beer Festival. We are however taking the opposite direction into North Street, once the northernmost extremity of the old town, now the main commercial thoroughfare and lined with major banks. It is a former bank, now the J D Wetherspoon outlet the Post & Telegraph that provides our second visit. The building of 1921–23 is in the Louis XIV style and faces the Edwardian-Italianate Midland Bank of 1902, designed by T. B. Whinney and still open as a branch of the HSBC if your cash reserves are running low at this early point in our walk.

We now cross North Street and head via the north section of Ship Street into Duke Street and to the Victory Inn, visually very attractive in its glazed-green banding. Leaving here we head to the bottom of Middle Street and the Hop Poles, originally the Spotted Dog and one of Brighton's oldest pubs. We are now in The Lanes, a network of twittens and walkways that formed medieval Brighthelmstone. When the oldest of the inns in this walk were first built, the only access to the centre of the old town from the beach was at the west and east ends, producing a cleavage in their custom. Middle Street marks the boundary of those inns patronised by the 'West-streeters', those residing in the western part of the town. When we cut through Ship Street Gardens, first to the Seven Stars, then the Cricketers, we have entered the old territory of the 'East-streeters.' As if by way of confirmation, the next two pubs, the Fishbowl and the Sussex, are both in East Street. We then cut through the alleyway by the side of the latter pub and to the Druids Head in Brighton Place. This area was once a plateau called the Knab and the centre of the Saxon settlement. We finish our walk just around the corner in Market Street at the Market Inn.

COLONNADE BAR, NO. 10 NEW ROAD

By 1854, John Edwin had turned these premises, previously occupied by a bootmaker, into the Colonnade Stores Refreshment Rooms. It was a hotel by 1859. As the ground-floor bar to the Grade-II listed Theatre Royal, it is now operated by the Golden Lion Group. The ornate frontage of 1894 by Charles Clayton is recessed under an elliptical arch with decorative spandrels flanked by pilasters with Corinthian capitals. The fanlights and doors have deeply etched glass. The narrow side walls carry tiled panels of thistle design by Webb & Co., London. Looking out from the canted bay is 'Willie', an antique automated mannequin dressed for the theatre. In 1935 the Colonnade Hotel made a loss and was sold for £5,750. Desirous to attract a high-class saloon lounge trade, new owner Mrs Edith Reeves intended a complete interior replacement and a new straight-lined façade in Roman stone or marble with a modified name 'Colonnade Long Bar' lit by neon sign. For reasons not clear, the work was never carried out, although had it been the premises might now be regarded as a fine example of functionalist modernism.

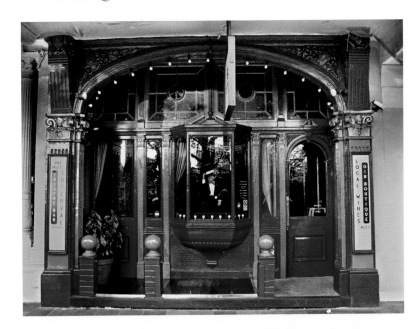

Colonnade Bar
with Willie the
mannequin.

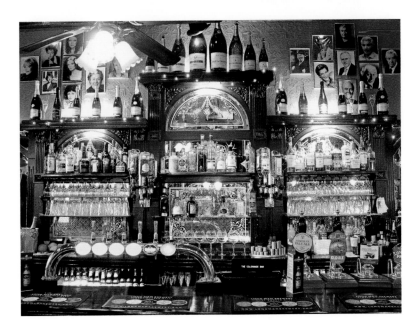

Mirrored back
fittings at the
Colonnade Bar.

In 1953 the hotel made a good profit after renovations and was repurchased by the
theatre for £5,900. The whole floor and joists had been replaced the previous year due
to woodworm attack. This necessitated the temporary removal of the old bar counter
and its carved back fittings with Britannia figure trademark. Both were shortened by
about ten feet before being reinstalled; the original point of extension is marked by the
cheaper quality timber that frames the mirrors each side of the three-bay bar back. A

partition once ran from the north-east corner of the counter to the still existing portion with etched-glass at the entrance. This created a large Saloon Bar and a small Private Bar then entered by the now defunct south door. The room retains its decorative plaster ceiling with moulded cornice at the rear. The surviving features make the Colonnade a CAMRA pub of regional heritage importance. One can feel so cosily cocooned within these soft-lit surroundings of autographed photographs of actors, ancient playbills, sumptuous curtain swags and red plush décor.

POST & TELEGRAPH, NOS 155–158 NORTH STREET

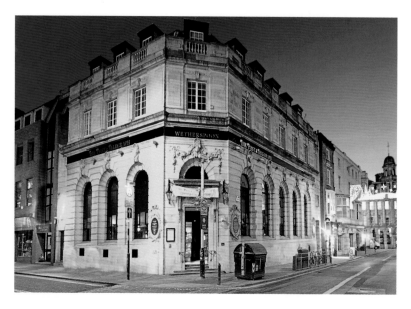

Post & Telegraph exterior (courtesy of J D Wetherspoon).

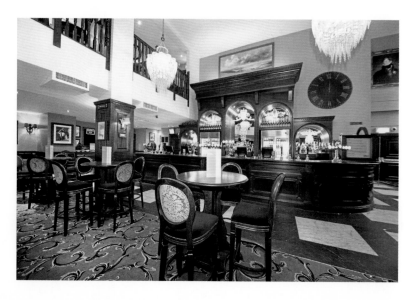

Post & Telegraph interior (courtesy of J D Wetherspoon).

This pub-restaurant inhabits a highly stylised stone building, Grade-II listed, constructed in 1921–23 for the National Provincial Bank. Designed in the neoclassical French style of Louis XIV by in-house architect F. C. R. Palmer with Clayton & Black acting as executants, it was harmoniously extended 1960–62 by B. C. Sherren. Of two storeys, separated by a wide entablature fascia, the rusticated ground floor has tall round arched windows, heavily recessed and with carved keystones. The main entrance at the chamfered corner is set within an architrave surmounted by an entablature with projecting cornice. Below is a bas-relief coat of arms on an escutcheon. A Diocletian window above has a female head keystone surrounded by carved swags. The double doors have zodiac-themed reliefs. At each side of this corner range is an elliptical escutcheon. The windows of the first floor are straight-headed below a projecting cornice with parapet. The latter has balustraded sections for all the dormer windows in the slate-tiled mansard roof.

The stylishly refitted interior is set out on two floors with a mid-level area on the North Street elevation. The focal point is the three-quarter height, Victorian-style bar back and servery along the east wall. Owners J D Wetherspoon often convert former chapels, cinemas, showrooms, supermarkets, banks and other such redundant buildings into pubs. They opened this, the third of their three outlets in the city, on 21 December 2010. It had closed as a bank in April 1994 when a branch of the National Westminster, a company formed in 1968 by the merger of the National Provincial and the Westminster. During much of the interim it operated as a bar and nightclub under various guises including Saqqara and The Gentleman's Turf. Its present name is derived from the fact that the bank was built on the site of several shops, including the premises occupied by the now defunct *Brighton Gazette, Hove Post and Sussex Telegraph*.

VICTORY INN, NO. 6 DUKE STREET

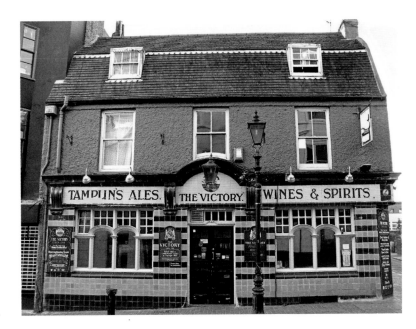

Victory Inn,
remodelled in 1911.

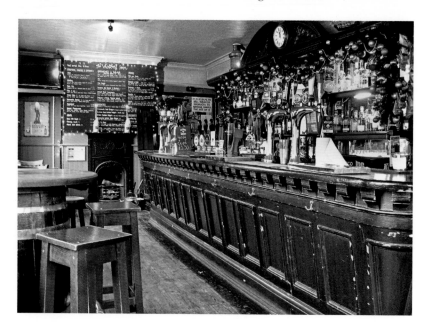

Victory Inn, front bar.

Exterior plaques state this pub to date from *c*. 1766 and rebuilt in 1824 to commemorate victory at the Battle of Trafalgar, 1805. This author has been unable to corroborate this claim. While parts of Duke Street predate 1799, no licensed premises named Victory are mentioned in any of the works on the old inns of Brighton and the first street directory in which this particular pub appears is that of 1854, with Thomas Gale as host, who in 1851 had been at the nearby Druids Head. The present building, with its dormers and distinctive gambrel roof, is early nineteenth century and Grade-II listed. The first floor is rendered; the ground floor in attractive glazed tiles of light and dark green banding is the result of 1911 alterations by Tamplins Brewery.

There are four sets of mullioned windows, glazed, elliptically arched and multi-paned. The entrance on Duke Street has a pediment with roundel depicting Nelson's ship. This would have given access to a Public Bar. The glass in the door around the corner indicates a Private Bar once at the west corner. A Saloon Bar, with its own small counter, was located along Middle Street where the disused single door is linked to the etched windows. The higher-level room at the south was created in 1991–93 by absorbing an adjacent shop. The main area retains a fine raked counter with sunken panels and three-bay mirrored bar back with turned balusters, entablature and scrolled pediment, but the clock is modern so the top part may be restored.

HOP POLES, NO. 13 MIDDLE STREET

Originally and for most of its existence called the Spotted Dog, this is one of the city's oldest pubs. Its host in 1791 was J. Buckman. This was during a period when the pub billeted up to a dozen soldiers and was well frequented by troops stationed elsewhere in the town. It was particularly popular with the South Gloucestershire Militia, whose barracks were at the West Street corner of Little Russell Street. It was said that the

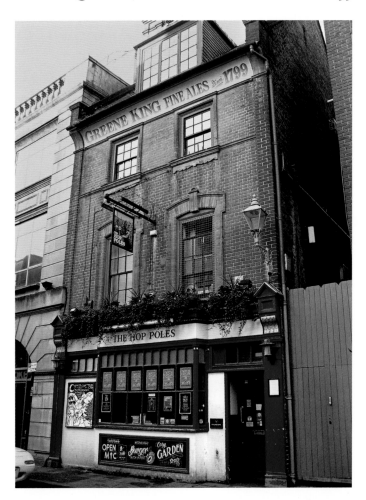

The Hop Poles, formerly the Spotted Dog.

The two Jess Gs, barmaids at the Hop Poles.

Spotted Dog 'never joyed after' these regiments were removed to other quarters; so much so that, in 1807, the then landlord, Mr Fairs, had the licence successfully transferred to the Richmond Arms, Richmond Place, which he opened for the first time as a pub.

The Spotted Dog remained a beerhouse until it acquired a wine license in April 1950. Its spirit licence came exactly ten years later, by which time the back bar had become a popular place for members of Brighton's burgeoning gay scene. They were entertained by a small but energetic pianist named Dolly. As her playing became more animated, the rattling of her bracelets and bangles provided an unintentional percussion accompaniment. When the more musically accomplished Beatles played over the street at the Hippodrome in 1964, their manager, Brian Epstein, and their lawyer, David Jacobs, drank together at the pub. Just four years afterwards, Jacobs, who had introduced Epstein to the local gay scene, was found hanged in the garage of his Hove home in circumstances never fully resolved.

In 1981, landlord and ex-policeman Norman Riches announced 'a complete change of policy and that gays were no longer welcome at the Spotted Dog'. A further break with the past occurred in 1998 when it was renamed the Hop Poles. A sense of history was restored in September 2011 when gay couple Dominic McCartan and Tony Leonard leased the pub from owners Greene King and called it the Spotted Dog Beer & Chop House. Their strategy was otherwise forward-looking, promoting the pub as an all-inclusive outlet for innovative craft beers. In 2012 the lease was taken for just three months by Martin Hayes for his first Brighton Craft Beer Co. Upon the removal of that business, the pub was operated by Indigo Leisure and reverted again to the Hop Poles.

SEVEN STARS, NO. 27 SHIP STREET

In the nineteenth century the signboard of the older inn on this site bore the inscription 'Established 1535', but Brighton had no surviving secular buildings of that period. It is documented only that the property was purchased on 29 April 1767 from Thomas Pumferry by Issac Grover, who founded the West Street Brewery in that same year. It is first referred to as the Seven Stars in a deed of enfranchisement of 1785, also by Grover so it is assumed that it was he who bequeathed the name of the house. By 1791 the licensee is a Mary Thorpe. It remained in the ownership of the West Street Brewery until 1897, when it was sold and rebuilt in the florid style we see today. Of three storeys, the first floor has a triple round arched arcade with recessed balcony flanked by oriels; the second floor has another recessed central bay but with a large single round arch, the façade rising to the highest and central point, a shield-holding griffin atop a pediment. Plans by architect Clayton Botham show that no less than eight such griffins were once (or were intended to be) symmetrically arranged around the top floor.

The interior boasted a long, central, island servery with adjustable counter screens and projecting low partitions that divided a Private Bar at the centre from a Public Bar at the south and a Saloon Bar along the north side, each with its own lobby entrance. On 24 June 1901, under licensee Isaac Benjamin De Costa, the pub provided the venue

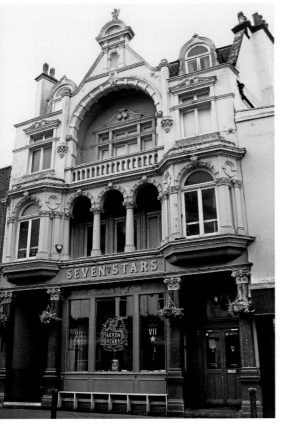

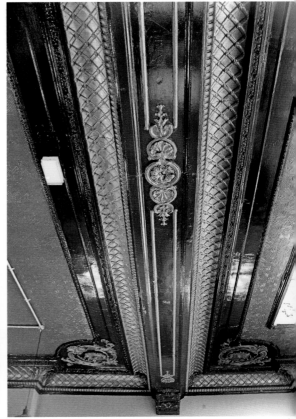

Above left: Seven Stars, rebuilt in 1897.

Above right: Seven Stars, original ceiling detail.

for the meeting that founded Brighton and Hove Albion Football Club. By 1929 the Seven Stars had passed into the ownership of Charrington Brewery, who erected a Snack Bar in French polished mahogany at the north-west corner and converted the first floor to a Club Room 'for beanfeasts, parties, dinners etc'. In 1953 they removed all the dividing screens and cut back the front of the counter to make one large Public Bar. One can only imagine what a magnificent aspect the original Victorian interior must have presented. In the late 1970s, the pub acquired a new identity as Flanagan's Seven Stars, and in 1997 became O'Neill's Irish Bar. The building was Grade-II listed in 1999. It has since reacquired its original name and, having recently been a Young's house, is now operated by Indigo Leisure.

CRICKETERS, NO. 15 BLACK LION STREET

This name was bestowed in 1790 by landlord Thomas Jutten, a keen player of the game. The inn stood in close proximity to the old fish market and was previously called the Last & Fish Cart – a last was a measure of 10,000 fish. Over the door

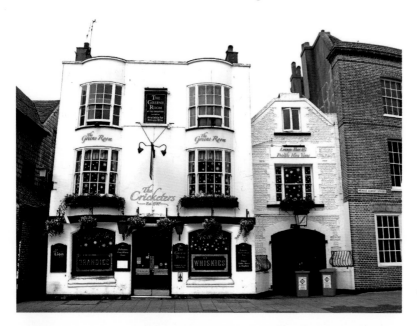

The bow-fronted Cricketers.

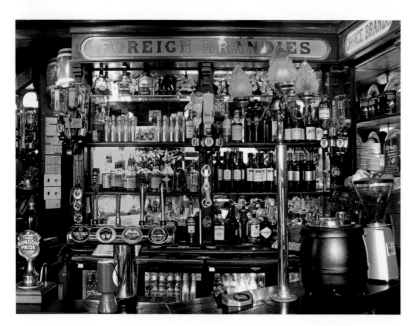

Bar back of 1886 at the Cricketers.

were the following lines: 'Long time I've looked for good beer. And at "The Last" have found it here.' The Grade-II listed building, three storeys in stucco, probably originates from the late seventeenth century, but its two full-height bows are from alterations of 1824. Although said to be the oldest continuous licensed premises in the city, there is no documentary evidence for the date of 1547 that is often cited, which probably

stems from confusion with the original Black Lion Inn (the pub of that name at No. 14 is a 1974 facsimile rebuilding of part of the Black Lion Brewery). At the north side is a stone and flint-fronted stable block, now converted to a drinking area. The door has its original securing chain. The yard beyond was the final site of the town's pound, where stray animals were placed and others parked by their owners. As recently as the 1880s a drunken drover had his flock of sheep impounded here.

The brass plates on the pub doors are indented R W PITT BRANDY MERCHANT. Robert William Pitt was the landlord responsible for the lavish refit of 1886, surviving features from which make this a CAMRA pub of regional heritage importance. Beyond the pair of isolated doors from a vestibule is the original counter, with thick pilasters and consoles and splendid back fittings that carry etched glass spirit advertising panels. The panel bearing the pub name is a modern addition. A small Public Bar and a carved cross-gantry with etched glass and projecting counter screen has been removed at this north side, *c.* 1973. The disused vestibule at the south wall gave direct access from the alleyway to the hotel accommodation. Guests were probably served from the rectangular opening in the counter at the rear lobby where an old pair of timbered archways separate side-by-side snugs. The drinking area here was expanded in 1949 when a former kitchen and large iron gate were removed. The early nineteenth century curved staircase leads to the Greene Rooms, with a set of exhibits on author Graham Greene. A sausage and Guinness supper at the Cricketers features in his 1969 novel, *Travels With My Aunt*. The pub's connection with Jack the Ripper is extremely tenuous.

FISHBOWL, NO. 74 EAST STREET

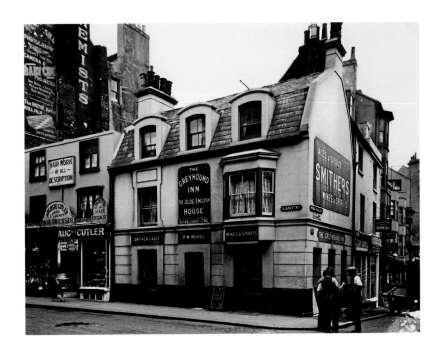

The Greyhound in 1929 before rebuilding (courtesy of the James Gray Collection).

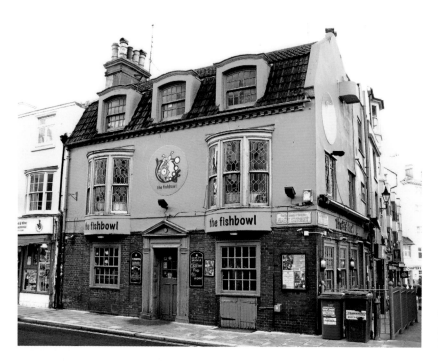

Greyhound rebuilt: now the Fishbowl.

A deed once in possession of a Mr Taylor, then owner of the adjoining residence, states this property to have been in existence by August 1658, with the land behind it an 'open garden to the easternmost wall in the Poole'. As an inn it was first known as the Anchor and operated as an unofficial auction house for fishermen's daily catch. By the late 1700s it was called the Greyhound. From 1826 it was owned by the West Street Brewery, eventually passing to Smithers, who in 1929 commissioned architects Clayton & Black to take in the adjoining premises to the east, a shop with office at No. 1 Pool Valley, and to give the rebuilt premises the neo-Georgian frontage that it retains today, with its three dormers, two bows and a portico. During the course of the conversions the local press commented that 'the size and solidity of the boulders which composed the original walls [of the inn] would alone indicate considerable age'.

The first floor room has its own story to tell. A branch of Ye Ancient Order of Froth Blowers, known as Aunties Vat (the choice of name is obscure), used to assemble there during the late 1920s, the proceedings conducted by pub licensee Percy Walter Morel. In 1948 a food license was held and the floor converted to an eighty-seat Dining Lounge. By the 1960s the upstairs had become a gay bar known as 'the G'. It was overseen by two ladies, May, who tinkled away at the piano, and Edie, who worked behind the bar and would discreetly allow patrons to leave notes for each other tucked behind Babycham bottles. The pub had been rebranded under its current name by 2003, but whether in knowing reference to its ancient association with fishermen is unclear. The upstairs room has transformed yet again and recently hosted a meeting of Homebrew Brighton.

SUSSEX, NOS 33–34 EAST STREET

East Street elevation of the Sussex.

Market Street elevation of
the Sussex.

Until 1816 this was known as the Spread Eagle and said to have been the haunt of smugglers. It was in existence by 1791 under the proprietorship of Grace Johnson. On 25 May 1794 the severed head of a prostitute was found in an adjacent public well. The house was renamed the Sussex Arms (later Hotel, subsequently Tavern, now in the diminutive). The Market Street elevation of this Grade-II listed building is an early nineteenth-century flat front affixed to the older premises. The bowed frontage onto East Street is probably from 1795, for an auction notice from August of that year refers to the 'new built or East part' of the house. It was at that time in the ownership of Mr Henry Skinner and leased at £30 pounds per annum to Mr Benjamin Tilstone. Mr Skinner's name was still listed alongside that of the public house in the 1800 directory.

In late 1927 the pub was acquired by Tamplins Brewery. Up to that point, the pub occupied only No. 33, but the brewery shortly afterwards purchased a portion of the shop premises at No. 34 and used the extra space to extend the Saloon Bar along the East Street side, also adding a small Public Bar at the north-east, the two rooms divided by a partition. At the same time, new toilet accommodation was added to the Lounge at the Market Street end; a new servery was built to allow supervision to all bars, while the lobby entrance with steps at the south-east corner was established. The wooden partitions separating the three rooms have long been removed, but much of this refit by Arthur Packham is still in evidence in the wall panelling, counter, back fittings, chequered bar apron and the tiled fireplace in the old Lounge.

DRUIDS HEAD, NO. 9 BRIGHTON PLACE

The name is apparently after a ring of stones once excavated nearby, originally placed there by the Druids. The whereabouts of this discovery can only have been the Old Steine (the name is said to derive from the Old English staene, meaning a place of stones). Workmen laying gas pipes there in 1823 unearthed a henge of Saracen stones, supposed to have once been arranged in a Druid's circle. The local fishermen used them to dry their nets upon before some were incorporated into the base of the fountain erected there in 1846, four years before the pub name first appears in street directories. The house received its beer license in either 1825 or 1830: if the application was first made under the Wellington Beer House Act then the latter year is the correct one. It was previously a private residence, possibly a fisherman's cottage and popularly stated to have been erected in 1510, but although refurbishment work of 1964 suggested that the property once stood in its own garden, Brighton has no surviving domestic buildings prior to the seventeenth century. This particular Grade II-listed brick and flint construction of rustic appearance has been more accurately estimated as late eighteenth century.

A bootlegger who slipped to his death on wet steps in his smuggler's passage on 2 August 1742 while pursued by customs officers, and is now said to haunt the pub, is just another romantic tale of old tunnels linked to coastal inns. It does not confirm that two blocked up passages in the pub cellar used to lead, one to the beach, the other to no less a place than the Royal Pavilion, both used for illicit purposes. Also unverifiable is the story of the flagstones of its floor originating from a local monastery. A twelfth-century chantry dedicated to St Bartholomew the Apostle and administered by Clunian monks did stand nearby until destroyed in a French raid of 1514 and enough

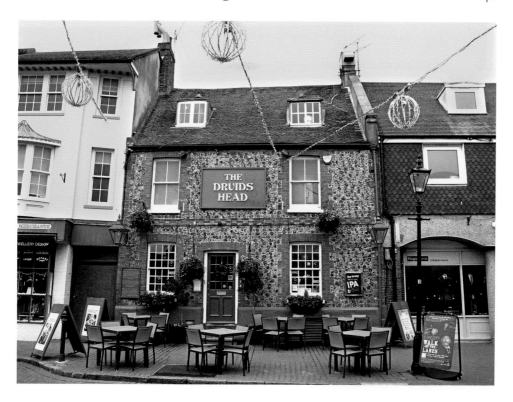

Above: Druids Head exterior.

Right: Flagstone at the Druids Head.

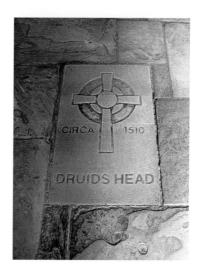

of the prior's lodge survived to be rebuilt as the residence of the vicars of Brighton until 1790, but no connection to the pub is flagged up on architectural plans. These do show that until the 1960s the now raised drinking area was a Bar Parlour separate from the front Public Bar, and the rear right was a Parcel Office, a remnant of when the pub doubled as Goods Carrier's House.

MARKET INN, NO. 1 MARKET STREET

Market Inn, formerly the Golden Fleece.

Island counter of 1927 at the Market Inn.

Until 1990, and from at least 1822, this inn was known as the Golden Fleece, but was originally called Chimneys, possibly built as a private house. Legend has it that its first resident was a chimney sweep employed at the Royal Pavilion and that the signboard of the inn consisted of a crude painting of a stack of chimneys, or three sweep's brushes, for some say the house was called the Three Chimneys. It is Chimneys in the 1791 directory with Aaron Batho as host, who is still there in 1805 when the house is well enough established to be known as Old Chimneys. Until 1850 the inn was in the hands of Wigney's Ship Street Brewery. It found its way via the West Street Brewery to Tamplins who in 1927 extensively renovated the building. During the course of the work, the outline of an inscription 'God Save King George III' was uncovered behind an old mahogany chimney piece on the first floor. The lettering was neither painted in nor gilded, possibly because the King's death of 1820 intervened.

The same alterations saw a new island bar on the ground floor allowing supervision over three rooms: a Private Bar to the rear left, accessed via a passage through the now disused left door; a Public Bar at the front left; and a Saloon Bar on the right side, both entered through a new central lobby but separated by a partition running to the bar counter. By the 1950s the pub attracted members of the gay scene who had a choice of two bars of very different character: one was quiet and run by a discrete elderly gentleman named Bert; the other was presided over by a flamboyant character called Dennis and was consequentially more carefree. The interior was opened up in 1969, but the old layout is still evident and the 1927 work by Arthur Packham otherwise remains intact, with superb island servery and back fittings, full-height panelling and much inset-leaded glass The ground floor windows were replaced in 1990, but the bow windows on the first floor of this Grade II-listed building are early nineteenth century.

From Lewes Road to the Pavilion via Hanover and Queen's Park

Brighton has the air of a town that is perpetually helping the police with their enquiries

Keith Waterhouse

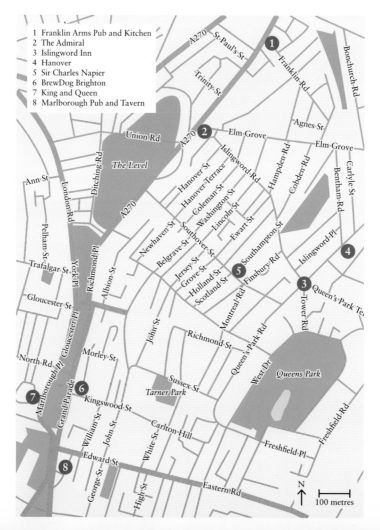

1 Franklin Arms Pub and Kitchen
2 The Admiral
3 Islingword Inn
4 Hanover
5 Sir Charles Napier
6 BrewDog Brighton
7 King and Queen
8 Marlborough Pub and Tavern

This is a long perambulation southwards through the spine of the city, via a short detour to Hanover at the north-east. We start at the Franklin Pub & Kitchen in Lewes Road, a 1957 rebuild in an area developed from the 1850s. Our second pub is the Admiral at the bottom of Elm Grove. Directly to the south are Hanover Crescent and Hanover Street, built *c.* 1822 by Amon Henry Wilds and which give this otherwise largely Victorian conservation area its name. Opposite is Park Crescent, once the site of the Royal Gardens of James Ireland, who in 1822 became the proprietor of the final pub on this walk. The gardens contained a cricket ground and one of its regular players was Thomas Jutten, landlord of the Cricketers pub in the second walk of this book. We have to tackle the incline that is Islingword Road to reach our third pub, the Islingword Inn, originally the Beaufort Hotel. In view to the north-east is our fourth pub, the Hanover. It was originally the Queen's Park Tavern, being in close proximity to the park of that name, which was first laid out as a subscription garden in 1824 but opened to the public in 1892. We retrace our steps past Islingword Road to Southover Street and to our fifth pub, the Sir Charles Naiper.

Cut through any of the south lying streets to descend Albion Hill. Phoenix Place at the bottom right stands on the site of Tamplins Phoenix Brewery. The brewery tap, the Free Butt, is boarded up. Adjacent are the offices of 1893 by C. H. Buckman, terracotta with a Phoenix emblem on the pediment. The original offices were in the bow-fronted regency terrace to the right. Walk south along the main road until Richmond Parade and the youth hostel that used to be the Richmond Hotel. This resemblance of this curved fronted neo-Georgian building to the second pub on this walk, the Admiral, is because it was designed by the same architect, J. L. Denman. We soon reach Grand Parade and our sixth pub, now the craft beer bar BrewDog Brighton but originally the Norfolk Arms. Almost directly opposite is Marlborough Place and our seventh pub, the King & Queen. After leaving here turn left to revisit architect J. L. Denman at the Allied Irish Bank, a building he designed in 1933, then the Citizen's Permanent Building Society. Note the carved reliefs of the building trades above the ground-floor windows. Denman is the behatted gentleman on the left. Walk south and admire or revile as you choose, the Royal Pavilion, remodelled in ostentatious fashion by John Nash from 1815–22, and of which Syndey Smith said 'it looked for all the world as it the Dome of St Paul's had came down to Brighton and pupped'. We then cross the road to our final and oldest pub on this walk, the Marlborough.

FRANKLIN ARMS PUB & KITCHEN, NO. 158 LEWES ROAD

Friday 20 September 1940 saw the start of a lunchtime session like any other for the staff and customers of the Lewes Road Inn, except for Sergeant James Frew who was on his last day of leave from the Royal Sussex Regiment and had just popped in for a pint and to say farewell. Barmaid Betty Marchant was just serving him when the pub took a direct hit from a lone German bomber that had been circling overhead. In the first seconds of silence that followed the explosion the air filled with floating feathers from burst pillows while curtains wafted in the upstairs window of the only part of the premises left standing. Betty Marchant dropped to the floor after being thrown by the blast against the bar, which acted as protective barrier by collapsing over her. She was

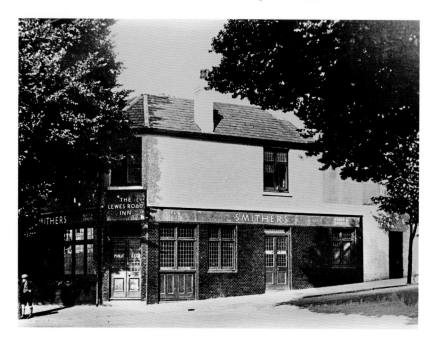

Lewes Road
Inn, 1920s
(courtesy of
the James Gray
Collection).

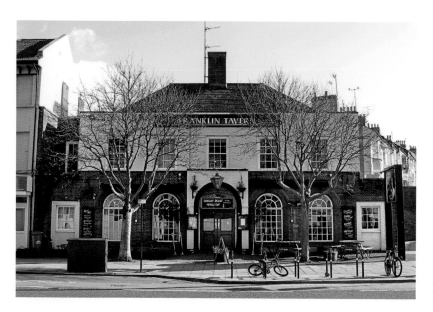

Franklin Tavern
(now Franklin
Arms Pub and
Kitchen).

the first to be pulled out alive and even managed a brave wave before being placed in an ambulance. The only mark on Sergeant Frew was made to the side of his head by the falling beam that killed him.

Licensees Ernest and Rosina Scully were middle-aged Londoners. Married in Lambeth in 1927, they moved in 1932 to the Lewes Road Inn, which was smartly modernised for them four years later. Mr Scully was heard calling out from below the rubble. The ARP

team and soldiers from the local barracks kept talking to him throughout the rescue attempt but both he and his wife had died before they could be uncovered. Also found dead on the premises was Violet Louise Pullen, unmarried, aged thirty-six, of nearby St Mary Magdalene Street. The body of window cleaner John Watson was discovered near the door. A small white terrier, Ruffy, who lived in the house next door to the Inn at the bottom of Franklin Road, escaped unscathed from the wreckage.

The original Lewes Road Inn was built in 1864 on land purchased by William and Charles Catt, later trading as the West Street Brewery. It was one of thirty-two pubs acquired in 1913 by Smithers. Although in 1929 it passed to Tamplins, it retained Smithers signage until the day it was destroyed. By December 1940, Brighton Corporation had requisitioned the bombed site with unintended but deadly irony as an air raid shelter, but had given permission for Tamplins to erect a small timber building along Franklin Road to which the license could be temporarily attached. Ten years later the brewery advanced plans for a larger, smarter prefabricated temporary premises. It is unclear if either of these interim measures was built but the present pub opened as the Lewes Road Inn on 12 September 1957. It was renamed the Franklin Tavern in 1991, with the current variation adopted in 2015.

THE ADMIRAL, NOS 2–6 ELM GROVE

As the Admiral Napier, this was first built in 1856 by a Mr G. Bowles at what was then Bright's Place, a small commencement of Lewes Road being constructed at this corner. The name is after Royal Naval Admiral Sir Charles John Napier (1786–1860), who served in the Napoleonic, Egyptian-Ottoman and Crimean Wars. The pub was badly in need of modernisation when it was acquired in 1929 from Smithers by the Kemp Town

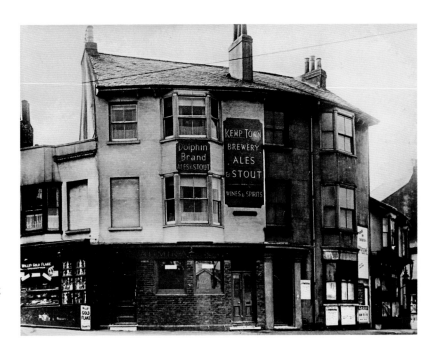

Admiral Napier before rebuilding (courtesy of the James Gray Collection).

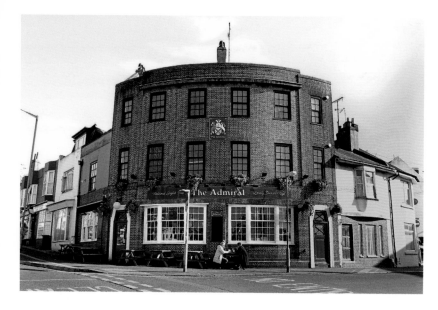

Admiral Napier, rebuilt in 1935, now the Admiral.

Brewery, who rebuilt it in 1935 – the date appears on both door lintels. The premises were expanded at the same time to absorb the adjoining property at the south-west, No. 2 Elm Grove, which became the new Private Bar; a Public Bar was provided at the opposite corner, with a Saloon Bar running along the rear. The pub retains its parquet floor of that period and the old three-room layout is still evident. The curved and elegant exterior is a quintessential neo-Georgian example from Denman & Son. Symmetrical and of three storeys, with hung sash windows, the centre four of its six bays are raised and recessed under a parapet with each of the projecting flanking bays carrying a ground-floor entrance with trapezoidal frame. In 2002 it was renamed the Sun, then the Flying Pig and later the Cornerstone. With half its old name restored, the Admiral was placed in 2015 on Brighton and Hove City Council's Local List of Heritage Assets.

The Architects

John Leopold Denman, 15 November 1882 to 5 June 1975, was born in Brighton and educated at Brighton Grammar School and the London County Council Central School for Arts & Crafts. He was articled to his father Samuel Denman in 1898, and in 1908 became an assistant at Jones & Smithers, London. He returned to Brighton the following year to take partnership in his father's practice at No. 27 Queen's Road. Having joined the Royal Engineers in 1914, Denman developed pneumonia and TB and was demobilised before the end of the First World War. In the 1920s he became a founder member of the Architecture Department at the Brighton School of Art and was engaged as in-house architect by the Kemp Town Brewery. It was in this capacity that he designed the majority of the brewery's improved public houses, usually in his trademark neo-Georgian style. He was made a Fellow of the Royal Institute of British Architects in 1928, by which time he was in partnership with his son John Bluet Denman as Denman & Son.

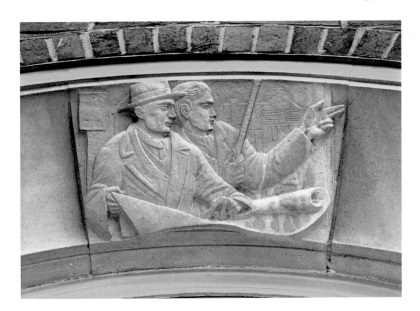

A behatted John
Leopold Denman:
Kemp Town
Brewery architect.

ISLINGWORD INN, NO. 175 QUEEN'S PARK ROAD

The pub first opened in 1869 with William Brown as its host, but may owe its present attractive appearance to alterations of 1896. Originally, and for most of its existence, the Beaufort Hotel (Arms in 1997), it spent a period from 2003 as the Duke of Beaufort before recently receiving its present name, which comes from it occupying the corner with Islingword Road. There were originally two entrances via a porch and steps on that south side. These were removed during alterations of 1932 by Arthur Packham for Tamplins Brewery, when the current lobby was established at the corner entrance. The

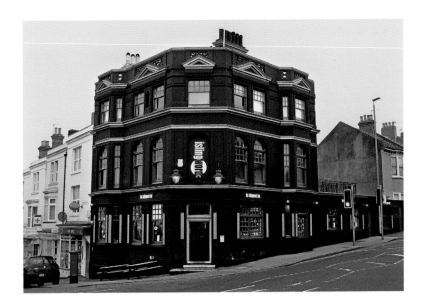

Islingword Inn,
originally Beaufort
Hotel.

Oak-panelled Saloon Bar at the Islingword Inn.

same work extended a Saloon Bar at the south-west and a Private Bar at the south-east corner. It also created a lobby entrance on the Queen's Park Road elevation to give access to a central Bottle & Jug and a Public Bar at the north-east. This latter was extended six years later by incorporation of a wash house and a children's shelter. It was further extended at the upper level in 1978. Although all remaining room partitions were removed in 1973, much high-quality 1932 work is still evident, particularly in the oak-panelled Saloon Bar. This retains its counter and two good brick fireplaces from that period. There is fine detailing in the slender columns of the bar back at the Queen's Park Road entrance. The counter at the south-east corner, former site of the Private Bar, is late-Victorian. The pub is now operated by Drink In Brighton. It is a CAMRA pub of regional heritage importance and in 2015 was placed on Brighton and Hove City Council's Local List of Heritage Assets.

The Architects

Arthur Benjamin Packham, 29 March 1866 to 7 November 1947, was born in Brighton, the youngest of three children to Henry Packham who was landlord of the Wheatsheaf in Bond Street in 1881–98. Arthur is recorded there as an architect's assistant in the 1891 census. He married Lizzie Mary Johnson on 3 April 1899 and the pair resided at No. 11 Caledonian Road, Brighton. A daughter appears to have died in infancy;

their son, Ralph Ernest Arthur, lived until 1981. Arthur Packham became architect and surveyor to Tamplins Brewery. He was an accomplished artist in black and white and a painter in watercolours. A member of the Sussex Records Society, Sussex Archaeological Society and the Brighton and Hove Archaeological Society, Packham was the author of *Illustrated History of Ditchling* (1901) and *Story of Shoreham* (1921). Walking was one of his favoured pastimes, through which he came to know the county of Sussex in intricate detail. He was a member of Brighton Ramblers Club and Sussex Folk Dancers.

HANOVER, NO. 242 QUEEN'S PARK ROAD

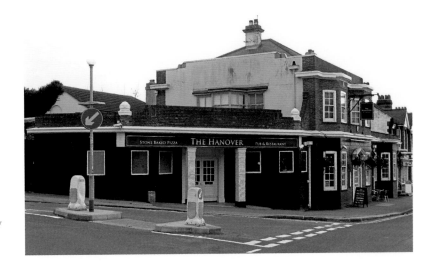

Hanover, formerly Queen's Park Tavern.

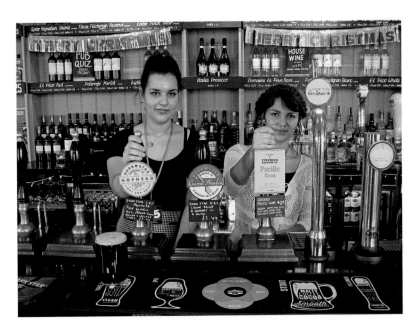

Zaynah and Mathilda pulling pints at the Hanover.

As the Queen's Park Tavern, this first appears in the 1855 directory at Reservoir Road under licensee Robert Coe. On 3 February 1859, his widow Emily took out a premises lease with local brewer William Hallett. By 1866 the licensee was William Emerson, whose directory listing of 1871 combines the Tavern with a dairy and makes reference to the Queen's Park Cricket Ground, then adjacent at the south-west. On 30 October 1874, Emerson filed his bankruptcy order. The brewery established by Hallett eventually became the Kemp Town Brewery, who in 1927 modernised the tavern to a design by Denman & Son. This was partly in response to the increase in the neighbouring population following the construction a few years earlier of the adjacent council estate.

It was intended to construct a commodious refreshment room catering for parties along the north side elevation in Down Terrace, but this idea was withdrawn in favour of the existing portico entrance with stepped parapet. This led via an inner vestibule to an Entrance Saloon with its own counter, and a separate Saloon Bar at the north-west corner. The three pedimented doorways along the Queen's Park Road elevation gave access to a Bottle & Jug, Private Bar and, at the south corner, a Public Bar that was further enlarged in 1930. A billiard room was retained at the rear. The interior was opened up and altered in the mid-1970s, but still falls into discrete areas and retains the front sections of the matchwood counter.

The 1927 exterior is essentially a neo-Georgian brick façade affixed to a Victorian building and remains intact. The supporting pillars of the portico are tiled in triglyph decoration, each bearing a monogram – the date of construction in the first instance, the initials of the brewery in the second. Two dolphins, the emblem of the brewery, entwine within a mosaic surround on the marble entrance floor. The frieze originally spelt out the name of the brewery in blue and gold. The pub subsequently became a Charrington house. It acquired its present name only relatively recently under current operator Indigo Leisure. Plans in 2000 to demolish the pub and erect twelve town houses on the site fortunately never materialised.

SIR CHARLES NAPIER, NO. 50 SOUTHOVER STREET

There are references to this pub being built or first licensed in 1855, but this part of Southover Street was seemingly not developed until 1859–64 and both the address and the pub first appear in the street directory of 1866. Judging by some of the old photographs now on display in the Snug, the assumption has been made that both this pub and the Admiral in Elm Grove take their name from the same man. It is equally plausible that the name is after Admiral Napier's first cousin and contemporary, Sir Charles James Naiper (1782–1853), British Army General and Northern Commander-in-Chief of India, who served in the Peninsular War and was responsible for the capture of Sind in 1842. The pub was definitely once owned by Abbey & Sons, a forerunner of the Kemp Town Brewery. Their plans from 1926 show that the corner entrance was then to a separate Public Bar along Southover Street. The now disused double doors midway along the Southampton Street elevation provided access to a Private Bar and Bottle & Jug. The single door at the end, still in use, was to a Saloon Bar. The Snug behind the 1950s partition was marked on the 1926 plans as a Bar

Sir Charles Naiper – named after the Admiral or General?

Sign-writer Rachel, also barmaid at the Sir Charles Naiper.

Parlour. This contains a tiled and wood surround fireplace of the period. The recessed square in the wall at the ladies toilets marks the site of a former storehouse. Some of this rear area was brought into use during alterations of 1979–81. The present counter is post-1926, but the back shelving seems considerably older. This a CAMRA pub of some regional heritage importance.

BREWDOG BRIGHTON, NOS 52–54 GRAND PARADE

As the Norfolk Arms, this first became a public house in 1854, then occupying a mid-terraced property dating from *c.* 1810. The present exterior is from a 1939 rebuild for Tamplins Brewery by Clayton & Black, who used buff-coloured bricks to match the appearance of the Brighton Municipal Market that first opened behind here in Circus Street in January 1937. The south wall of the pub recently bore the slogan 'Beer is Art', a concept that would have been incomprehensible to the workers and attendees of the market, for whom the Norfolk Arms was specially licensed between the hours of 6.30 a.m. and 8.30 a.m. on Tuesday, Thursday and Saturday. Another person taking

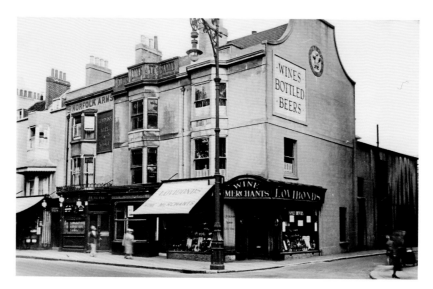

Norfolk Arms before rebuilding (courtesy of the James Gray Collection).

Beer is Art at BrewDog Brighton.

advantage of the early opening hours was wife-murderer John Dorgan, who left the pub at 8.30 a.m. on Saturday 31 August 1943, having continually stood drinks for a Canadian solider, Dorgan spending the money he had raised from selling his dead wife's possessions. By 1993, this became the proverbial pub with no beer as the non-alcoholic venue, Norfolk LA. In 1997 it became Hector's, subsequently the Blind Tiger Club, and then closed for while before being taken on by BrewDog Brewery who renovated the interior in industrial style and reopened at the end of August 2015.

That there was a two-year delay in pushing through the plans for the 1939 rebuilding provides another example of changed social attitudes. The problem was not the proposal to extend the drinking area by absorbing the adjoining premises but the radical idea of having a Saloon Bar in the basement. This was a step too far for the chief constable of Brighton, Capt. Hutchinson, who tersely responded: 'I think it is a retrograde step in a seaside resort to introduce basement saloons into public houses. I return the plans herewith.' Under the impression that the objection was because the basement would have no natural sunlight, Clayton & Black persevered with revised plans, meticulously detailing the exact angles at which the mid-winter and mid-summer sun would strike the basement service wall from proposed windows along the Carlton Hill elevation and thereby illuminate the large proportion of the area. Hutchinson, for whom beer was never going to be art, remained unmoved and the pub was eventually built with all bars on the ground floor – an historic chance missed to become Brighton's first basement saloon bar.

KING & QUEEN, NOS 13–18 MARLBOROUGH PLACE

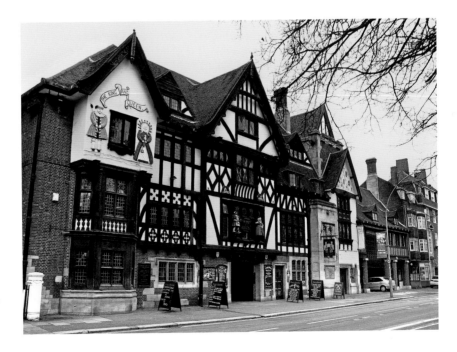

Pantomime time. The mock-Tudor King & Queen.

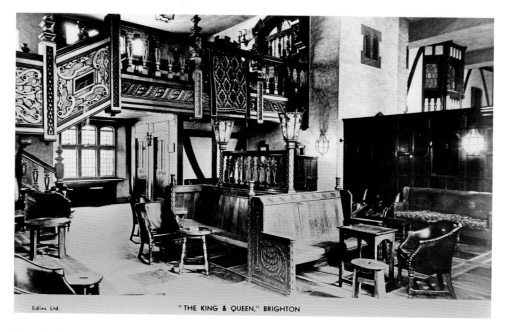

Edlins Ltd. "THE KING & QUEEN," BRIGHTON

King & Queen interior (courtesy of the James Gray Collection).

Pastiche if not parody, although some have called it pantomime, this remarkable exercise in interwar Brewers' Tudor is a stylised showcase of sixteenth-century vernacular architecture in virtually every possible building material. Although described at the time of construction as 'a gorgeous flight of architectural imagination', some locals accused the owners Edlins of architectural vandalism. A farmhouse built on this site in 1723 at what was then No. 1 North Row was licensed under its current name by 1779 (a case of coins of the Hanoverian era was unearthed during the 1930s renovation). The area then consisted of rough grassland and the ground in front of the inn was known as 'The Level'. It hosted various sporting events including, in 1807, a sparring match between prizefighters John Gully and Tom Cribb, witnessed by the Prince of Wales. Four years later fraudster John Fuller was confined at the inn prior to being taken to stand for one hour in the stocks. It was the town's first pillorying: Fuller had attempted to pass off a 2*d* note for one of £2. The inn housed an excise office from 1848–54 and the corn exchange until 1868. It was a two-storey, triple-bow-fronted hotel when local firm Edlins acquired it in 1909, after which it incorporated their company office, family-run garage and a separate dance academy.

Work began in 1931, to plans by Clayton & Black for a building tender of £25,428, resulting in the existing Grade II-listed building. The first-floor foundation stone laid by Emily Edlin bears this date. A second phase from 1935–36 saw the gatehouse and portcullis erected to provide a stagy entrance into an open-air galleried courtyard with fountain and pond. The latter have since been paved over, but decorative tile work survives. Interior design was by Ashley Tabb, of Heaton, Tabb and Co. Ltd., who created two large bars, Public and Saloon, with galleries, Tudor fireplaces, heraldic

motifs, stained glass, shields, carvings, emblems and other such fanciful features. A small panelled room at the south-west has a replica of the eighteenth-century hatchway through which ale was once passed through to soldiers stationed at barracks behind the inn. A Ladies' Parlour was originally sited at the south-east and the upstairs suite, with barrel-vaulted ceiling, was designed as a children's room. A wooden screen that ran from the counter to divide the bars was removed during alterations of 1968 to open up the interior. Enough of the 1930s work remains, nonetheless, for CAMRA to regard this as a heritage pub of national importance.

The Architects

Clayton & Black were a local firm of architects and surveyors founded in 1876 by Brighton-born Charles E. Clayton (1853–1923), originally with George Holford (until 1883) and from 1882 with Ernest Black (1855–1917). They had premises at No. 152 North Street before moving in 1904 to No. 10 Prince Albert Street. The firm continued under sons Charles L. Clayton and Kenneth R. Black. Working in an eclectic range of styles, they were hugely prolific in their contribution to the late nineteenth- and early twentieth-century expansion of commercial, domestic and ecclesiastical buildings across Brighton and neighbouring Hove. Of the pubs in this book, the firm was responsible for rebuilding the Greyhound (1929), the King & Queen (1931–36), and the Norfolk Arms (1939). The practice was reconstituted after the early 1950s as Clayton, Black & Daviel before ceasing *c*. 1974.

MARLBOROUGH PUB & THEATRE, NO. 4 PRINCES STREET

As the Golden Cross, this appeared in the 1791 directory with Mr Eldridge as host. It was leased by the Southwick Brewery in 1795 to Henry Witch and in 1806 to George Howell. By 1822 it was presided over by James Ireland, a prosperous draper and undertaker who was also the original proprietor, from 1823–26, of the Royal Gardens and Cricket Ground on the part of The Level now occupied by Park Crescent. The Brighton Royal Catch & Glee Club, a subscription music society, met at the inn every Tuesday evening during this period. The days of the Golden Cross as place for fashionable society ended in 1849 when the holding brothers James and William Creech, who had borrowed against the property, were made bankrupt and the contents of the twenty-room inn seized and sold by the county sheriff to discharge the debt. In 1854 it reopened as a Victorian pub called the Marlborough Tavern; forty-five years later it was the scene of a wife-killing.

PC Mullins was passing the Marlborough around midnight on Thursday 1 March 1900 when he overheard a woman inside pleading 'don't' Tom'. A man's voice chided, 'you're a lazy woman', to which the woman replied, 'I know I am'. The constable returned with colleague PC Puttick who heard the man inside threaten 'I'll kill you'. Then came the sound of a thud as if a body had hit the floor. The live-in potman later found landlady Lucy Packham lying at the foot of the stairs with husband Thomas standing over her imploring her to get up. She never did. Tom Packham was drunkenly remorseful, but Lucy had been badly beaten and died of a cerebral haemorrhage. The inquest, upstairs at the Marborough, heard of the history of abuse she had suffered

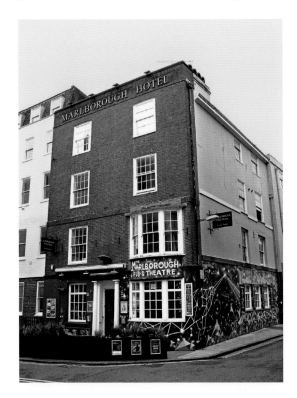

Left: Scene of a wife-killing: Marlborough Pub & Theatre.

Below: The Lucy Packham room at the Marlborough Pub & Theatre.

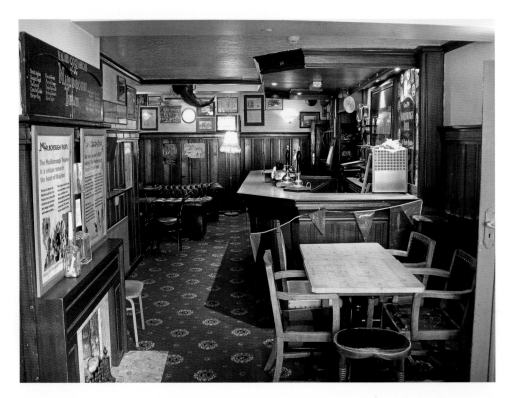

at the hands of her husband and returned a verdict of wilful murder against him. Yet when it came to the trial, eloquent defence barrister Edward Marshall Hall persuaded the all-male jury to find Packham guilty only of the lesser charge of manslaughter.

Postscript: A few years ago, a female customer, a stranger to the pub, came in, ordered a coffee, and took it round to the timewarp lounge bar to drink alone. She soon returned saying that she simply must leave because of experiencing intense, unsettling feelings about 'a woman who wanted her story told again'. She could not have known that a framed set of cuttings about Lucy had not long been removed from the wall of that bar. Lucy's story is now again on display and this author can vouch that the atmosphere there was entirely peaceful when he took the photograph. The room where Lucy's inquest was held was converted to a theatre in the 1970s. The pub has since had links to the LGBT community.

St James's Street to Kemp Town

Brighton is still very gay and full of balls

Samuel Rodgers, 1829

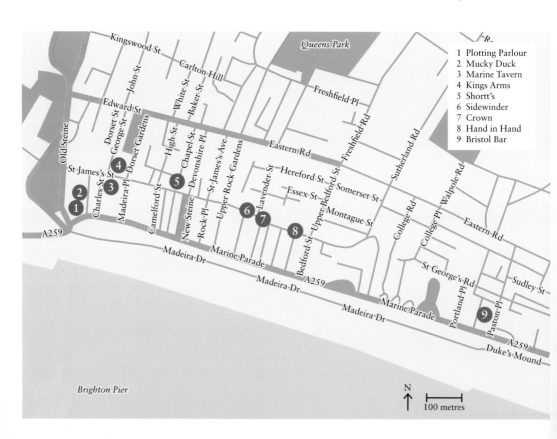

1 Plotting Parlour
2 Mucky Duck
3 Marine Tavern
4 Kings Arms
5 Shortt's
6 Sidewinder
7 Crown
8 Hand in Hand
9 Bristol Bar

We begin this walk at the bottom of St James's Street, the major shopping thoroughfare of the eastern part of Brighton and now a centre for the gay community. It was formerly a 'leek way'– a wide path that separated the furlong strips of the open fields once here, known as The Lanes, hence the grid pattern of the subsequent development. The streets that house our first four pubs were set out in the final two decades of the eighteenth century. The Plotting Parlour bar in Steine Street was previously named the Aquarium Inn after the nearby Brighton Aquarium. This famous seafront attraction was designed by Eugine Birch in Italianate style and opened in 1872 with extensions in 1874–76. It was completely rebuilt in Louis XVI style in 1927–29 by the borough surveyor David Edwards. In 1964 Mods and Rockers fought on its sunroof. The other licensed house in Steine Street, Broadway Bar, was previously the Queens Head, as can still be seen on the chimney stack. Until its recent change of name, the signboard depicted the head of Freddie Mercury (the late singer with the band Queen). After visiting the Mucky Duck, Marine Tavern and the Kings Arms, we walk eastwards to our fifth pub, Shortt's, passing along the way Madeira Place, running down to the seafront. Here, in a basement property now part of a guest house, John Dorgan murdered his wife then sold her possessions at the two aforementioned pubs in Steine Street.

The Sidewinder and the Crown are our next two pubs on this walk. Opposite, once stood the Rock Brewery at No. 61 St James's Street, amalgamated in 1928 with the Portsmouth and Brighton United Breweries. The brewery was demolished in 1978, the site now occupied by Lavender House and St Mary's Church House. We now find ourselves in Kemp Town, after Thomas Reed Kemp who set out the elegant estate with its grand houses and squares at the eastern end of the seafront. The Kemptown Brewery that was established in 1989 at our eighth pub on this walk, the Hand in Hand, is not the Kemp Town Brewery that once stood to the north of our final port of call, the Bristol Bar. The hotel of that bar and the brewery were both established in the 1830s by William Hallett. The brewery was demolished in 1970, the site now occupied by the Seymour Square development. Buses back to Brighton run regularly from this point at Eastern Road or the seafront, but first pause to admire the curious Indian-featured building at the corner here with St Georges Road. It was originally a mausoleum for Sir Albert Sassoon, a Baghdad-born merchant with links to Bombay. In 1953 it was purchased by the Kemp Town Brewery and amalgamated with the next-door Hanbury Arms as the Bombay Bar. It is now home to Proud Cabaret, but the bar name remains in stonework over the Paston Place doorway.

PLOTTING PARLOUR, NO. 6 STEINE STREET

Recently renovated, renamed and reopened as a bar, these premises have a long history as a pub. Originally called the Packet Inn or the Brighton Packet Inn, after the cross-channel packet boats that departed from the shore from the late 1700s, it was in existence by 1822 under landlord Thomas Heather, but may have received its license earlier. By 1828 the host was George Fullick, whose family was to run the pub for over thirty years. His daughter Mary Maria had taken over by 1851. She was to keep the inn, later assisted by her niece, until Saturday 16 April 1869 when she threw herself from the second-floor window. She never regained consciousness and died four

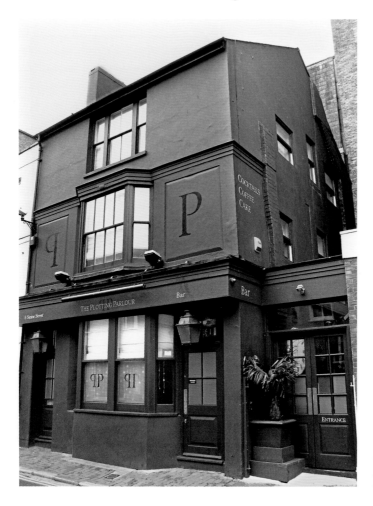

Plotting Parlour,
previously the
Aquarium Inn.

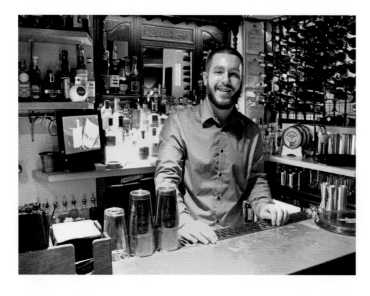

Jake behind the bar at
the Plotting Parlour.

days later from compression of the brain. The inquest, also held at the Packet Inn, heard that the fifty-three-year-old spinster had for several years been suffering from depression and had lately been heard to make remarks that she should do something towards herself. She had tried to commit suicide around five years previously and one of her sisters, Kate Eliza, had succeeded in taking her own life in 1861. The inquest returned a verdict of suicide under temporary insanity.

From 1874 this became a West Street Brewery house and was renamed the Aquarium, after the seafront aquatic attraction. The pub subsequently passed into the ownership of Smithers Brewery and was acquired by Tamplins in 1929. From 1916 until 1939 it was run by Mr and Mrs Frank and Rosa Hilson, in whose period of tenancy during the late 1920s it operated as a Vat for Ye Ancient Order of Froth Blowers. At 8.30 p.m. on Saturday 31 August 1943, First World War veteran John Dorgan, aged forty-six, was arrested in Steine Street after travelling by taxi to the pub from Western Road for his second visit of the day, having previously been there at 6.00 p.m. buying drinks for everybody in the bar. He had been treating customers in the nearby Queens Head from 10.00 a.m.–2.30 p.m., having started the morning at the Norfolk Arms. Dorgan had murdered his wife a few days previously and his free spending was due to the proceeds of the sale of her possessions, some of which he had flogged in the pubs. This was a LGBT pub in more recent times until its transformation into the Plotting Parlour.

MUCKY DUCK, NOS 7–9 MANCHESTER STREET

Deeds of the terraced house at No. 7 date back to December 1793. From 1861 to 1865 it operated as Dining and Coffee Rooms under proprietor Elizabeth Domine, with the name Star Inn first appearing in the final year. In 1866 the licensee was Thomas

Mucky Duck,
originally the
Star Inn.

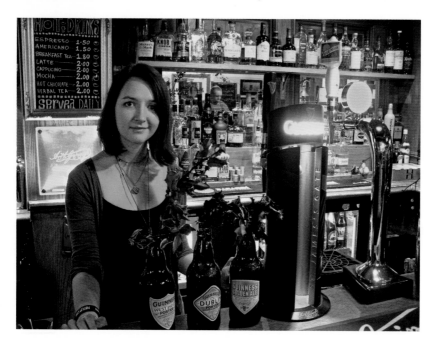

Lifeguard Amy, also barmaid at the Mucky Duck.

Masterman. Percy Walter Morel was the landlord in 1915/16 before moving across the Old Steine to the Greyhound in East Street. The chief constable of the following decade remarked that the Star was always crowded and congested during the summer months, so in 1930 it was expanded to include the previously unlicensed premises at No. 8 and given its light-green, tiled ground-floor fascia. Plans by Stavers Hessell Tiltman for the Portsmouth and Brighton United Breweries show a Public Bar at the south and Saloon Bar at the north, both with their own lobby entrances. Seven years later, the Saloon Bar was further widened at the north end by absorbing what had been the corridor to the upstairs flat at No. 8, in the process of which the ground-floor door to that property was bricked up, its arched surround left intact.

By 1997, the pub had been acquired by the Golden Lion Group and renamed the Golden Lion Tavern. Further work had been undertaken in 1982 and 1995 to absorb part of the property at No. 9; the resulting uneven arrangement of the pub accommodation on its various floors led the landlord of the time, Marcus, to describe it as a 'zigzag pub'. He recounted that until 5.00 p.m. on millennium eve, the now plain window in the fascia was etched with the word 'wines' just as its companion still says 'spirits', but was smashed by irate customers who objected to Marcus's attempts to close the pub early. The area then had a drug problem, so to deter users slipping unnoticed from the street to the recently installed basement gents, Marcus fitted the first keypad coded entrance to a pub toilet in Brighton. As the Mucky Duck, and Grade II listed, it is now the type of pub that hosts pop up pottery workshops and where the timber-framed door to the downstairs toilets can be safely left ajar. Yet Marcus's keypad remains and the green light even comes on when the keys are pressed.

The Landlords

Son of a dairyman, Percy Walter Morel was born in Marylebone, London, in July 1872. He initially worked as a printer's compositor and linotype operator. In 1889 he married Hounslow-born Martha Alice Agnes Cutbush. The couple lived in Twickenham before moving to Brighton in 1905 to set up a stationers and newsagent shop at No. 61 London Road, specialising in scenic Sussex village views. In 1915 he gave up the business to become landlord of the Star Inn (now the Mucky Duck). Licensed victualling perhaps ran in Percy Morel's blood – his grandfather, Francis Edward Morel, was First Master Cook of King George IV and author of prized books on gastronomy. By 1917 Percy had moved to the Greyhound (now the Fishbowl) staying there until 1931, after which he went with his wife on month's cruise to North Africa and the Far East before retiring. He died aged seventy-two in Hove on 10 September 1948. His wife survived him until 13 April 1963. They do not seem to have had children.

MARINE TAVERN, NO. 13 BROAD STREET

By 1856, Thomas Venus had set up as a greengrocer and fruiter. Two years later he is supplementing his income by beer retailing and has decided on the name Marine Tavern by 1859. In 1934, at a cost of £400, the tavern was refitted by the Portsmouth and

Marine Tavern flying the rainbow flag.

Marine Tavern landlord Lee Cockshott (in blue trainers) with customers.

Brighton United Breweries and given the green tiled and faience treatment distinctive of many of their houses. Plans by Stavers Hessell Tiltman show the premises occupying the same long and narrow space as they do now. A new counter was fitted; a partition was removed that previously divided the front area into a Public Bar and Private Bar, but a door and screen running from the west end of the counter to the stairs allowed entry to a separate Bar Parlour at the rear.

It was not until 6 February 1952 that a wine license was secured. The full-height field panelling at the rear mostly likely dates from alterations of that year. Two years later the tavern passed into the ownership of Brickwoods Brewery who in 1971 gave it the new frontage it has to this day. It was acquired at the end of that decade by Whitbread, and during the 1990s it was operated by the Golden Lion Group. This small but perfectly formed pub is now owned by Admiral Taverns. Popular with the LGBT community it is, according to landlord Lee Cockshott, colloquially known as the 'Gay Cheers'. The retention of the old counter and panelling make it a CAMRA pub of some regional heritage importance.

KINGS ARMS, NO. 56 GEORGE STREET

Probably the first property to be built in this street, it would have been of relatively recent erection when it appeared in the directory of 1799, with Henry Gillet as host. By 1811 a cockfighting pit had been established in the yard. A match commencing at 11.00 a.m. on 17 January that year offered a prize of 5 guineas for the winner of each battle and 20 guineas for the overall victor. In July 1816 the house was the scene of another wager. A Captain Wombwell of the 1st Life Guards had bet 500 guineas that he could ride a tandem from the Marsh Gate, Westminster Bridge, London, to the Kings Arms without changing horses. Despite torrential rain falling throughout his

Scene of many wagers: the Kings Arms.

52-mile journey, the captain arrived at the appointed place at 8.45 a.m., having set out at 4.00 a.m., and with his horses not much put out by the ordeal.

A number of the town's tradesmen who wished to combine business with pleasure habitually frequented the inn at this time. At one such gathering there arose the laudably patriotic idea of erecting a statue on the Old Steine to George IV. The famous sculptor Chantrey was contracted to undertake the work for a stipulated sum of 3,000 guineas. Unfortunately, a subscription did not realise the necessary amount, despite the list remaining open for over eight years and, to make matters worse, the statue eventually cost the sculptor twice the original amount agreed. The Kings Arms has presented the same aspect to the street since Victorian times: two bays, rusticated ground floor and portico entrance with Doric columns. Its Spartan interior with Sky Sports screen appears somewhat at odds with its history.

SHORTT'S, NO. 46 ST JAMES'S STREET

As the Royal Oak, this was operating as a posting house by 1817 under the ownership of Matthew Walker, a gentleman of Brighton. An auction notice of 1827 describes it an 'old established inn', its estate consisting of a billiard room and tap (The Royal Oak Tap was at No. 36), a range of stables and coach houses in Chapel Street, adjoining, and a piece of copyhold land at the back. The purchaser may have been Edward Foard, who on 27 June 1831 respectfully informs the inhabitants and visitors of Brighton that he has succeeded in completing the improvements in this Commercial Inn and Family Hotel. Foard did not prove to be much of a businessman for on 19 March 1832 the premises were sold by auction under a commission of bankruptcy against him. It was described as the Royal Oak Tavern Hotel, Coffee House and Wine Vaults with stabling, tap and appurtenances of considerable extent in St James's Street, Brighton,

Shortt's, formerly
the Royal Oak.

Owner Val Shortt
behind her bar.

opposite the Steyne, leasehold for twenty years at a rate of £308 per annum. In 1842 it was known as the Royal Oak Wine and Spirits Vaults under the proprietorship of William Sims. By 1850 it was owned by Wigney's Ship Street Brewery, who sold it in July of that year to Vallance and Catt – later the West Street Brewery.

By 1880 a share in the Royal Oak was sold to Simonds Brewery of Reading, who purchased the remainder in 1895 for £4,060. In 1932 they took the decision to demolish

what had become a property so old as to be incapable of being remodelled, and erect the modern pub on the site that remains today. Designed by E. Wallis Long, it had a public bar at the south end with two lobby entrances along the St James's Street elevation; a Private Bar and Bottle & Jug Department had its own entrance in Chapel Street; a Saloon Bar was further north, also with its own entrance. Subsequent alterations were made over the years to enlarge the area allocated to the Public Bar. In 1960 Simonds and its stock of pubs was acquired by Courage Brewery. The pub has since changed hands a number of times, most recently in 2015 when it was renamed Shortt's after its new family owners. The opened-up interior still falls into discrete areas and Wallis Long's 1932 work survives in the bar counter and back fittings, albeit truncated in the old Public Bar, and in the superb fireplace in the north-east corner of what was the Saloon Bar.

SIDEWINDER, NO. 65 ST JAMES'S STREET

On Thursday 25 March 1886, this was the scene of a double killing. George Henry Metcalf had married Alice Elizabeth Williams three years previously and was working as a perfumer's assistant when advanced money by his father-in-law to become landlord of the Lion Inn, as it then was. Metcalf drank heavily, ill-treated Alice and had a breach of promise action pending against him by a young woman of Leeds. Things came to a head when Metcalf dismissed the barmaid, threatened his wife, then gave his notice to the brewers. For a fortnight he lodged at the neighbouring Crown Inn, Grafton Street. In the meantime, Mr Williams had himself taken on the Lion to retain his daughter's livelihood and had also reinstated the barmaid. At 3.00 p.m. on the fatal Thursday, Metcalf entered the Bar Parlour at the south-east corner, engaging in conversation with the barmaid and a customer. Metcalf managed to slip unnoticed up the adjacent stairwell where he met his wife on the upstairs landing, she having been dressing in

Sidewinder,
formerly the Lion.

Hannah and Max, licensee and barman at the Sidewinder.

her bedroom. He shot her in the breast, neck and arm before going to a room on the second floor where he blew out his brains with the revolver he had purchased from a pawnshop.

The Lion first appears in the directory of 1854, with Mary Harvey as the host. It was a West Street Brewery house until sold in 1898 to the Pitt family. The following year Robert William Pitt, also landlord of the Cricketers, had the Lion refronted in the style still showing the ground-floor fascia with pilasters and consoles, curved at the lobby entrance to what was then the Private Bar. There was originally a lobby at the east that gave access to a Public Bar. At the rear was a Saloon Lounge. A slender hallway stood along the west wall. All rooms were supervised by a central island counter. In 1904 it is advertised as a Hotel with Livery Stables (at the exit in Atlingworth Street); by 1918 the latter had become a garage. This was demolished in 1990 when major alterations took place to extend the pub to the south and create the beer garden at the side. The rear conservatory extension, now home to a Buddha, was fitted in 1998. The crabby change of name came by 2002. Having been owned by Kidd & Hotblack, Tamplins, and Watneys, among others, it is currently operated by Drink In Brighton. In 2014 it was named by the *Argus* newspaper as 'the best pub in Brighton'.

CROWN, NO. 24 GRAFTON STREET

The original inn on this spot was opened by 1832 under landlord Thomas Wicks. He was succeeded later that decade by William Marchant who operated the Crown as a stopping point for coaches. In March 1886, George Henry Metcalf, ex-landlord of the nearby Lion Inn (now the Sidewinder) stayed here for a fortnight before returning to his old pub to kill his wife and commit suicide. In 1934, the Crown was modernised at a cost of £900 by Stavers Hessell Tiltman for the Portsmouth and Brighton United Breweries. The present brick frontage was provided, with the south door then giving

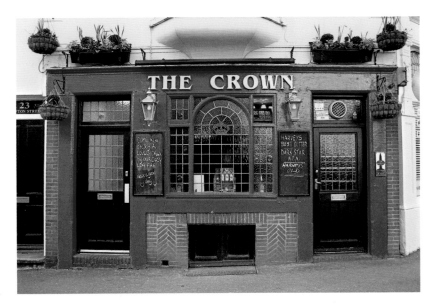

Crown frontage.

Oak-panelled
interior of the
Crown.

access via a lobby to a large Saloon Lounge at the rear and a compact Public Bar
at the centre front; a Bottle & Jug department was accessed at the north door. The
interior was panelled in oak and fixed seating was provided at the front and rear
walls. A new servery was erected along the north wall, and a new fireplace fitted at
the north-west. The flimsy partitions separating the three rooms were removed in the
1960s, but the charming 1934 interior otherwise remains intact, to the extent that it

was chosen as the front cover image for this book. Green leaded 'United Ales' lettering originally appeared below the red-cushioned crown in the centre panel of the leaded front window, while 'Saloon Lounge Public Bar' was on the panel of the south door, this artwork only recently removed, a small scar on what is otherwise a remarkable survivor and a CAMRA pub of regional heritage importance.

The Architects

Stavers Hessell Tiltman, 2 August 1888 to 28 August 1968, was articled to Alfred Hessell Tiltman, 1904–07, then acted as his assistant, 1907–09. He attended evening classes at Regent Street Polytechnic and was Head Draughtsman to J. Barnes & Son, Brighton, 1909–12. Tiltman established an independent practice in Haywards Heath in 1912 and served from 1914–19 with the Royal Engineers and Sussex Yeomanry. Following his discharge, he became architect and engineer to the Rock Brewery, Brighton – afterwards the Portsmouth and Brighton United Breweries. From 1927 he practiced from No. 42 Middle Street, Brighton, being responsible for the subsequent alterations to many of that brewery's houses distinguished by the favoured use of green faience tiling. His best-known design however is probably the Art Deco terminal building at Shoreham (now Brighton City) airport. Tiltman was made a Fellow of the Royal Institute of British Architects on 11 January 1937. One of his three proposers was John Leopold Denman.

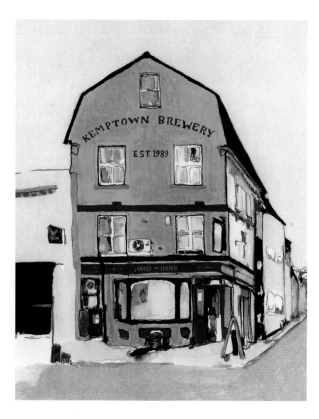

Hand in Hand illustration (courtesy of Victoria Homewood).

Lamp-lit signage at the Hand in Hand.

HAND IN HAND, NO. 33 UPPER ST JAMES'S STREET

A beer license was first obtained here in 1858 by a Mrs Harmer, with the name Hand in Hand appearing the following year. For a few years from 1868 it was called the Gasfitters Arms after licensee Henry Elms, who was engaged not only in that trade but went by the now impossibly archaic-sounding occupation of bell hanger. A photograph from *c.* 1918 shows it with signage for Abbey & Sons, forerunners of the Kemp Town Brewery. If the small but perfectly formed single-bar feels cosy and intimate, consider that before 1960 this was three rooms. Behind the piano was once an entrance to a Private Bar that ran behind a partition along the east wall where the servery is now situated. The Public Bar was entered via the existing corner doors but the counter was then aligned east–west. Behind this stood a Saloon Bar at the south. Spot the disused door along Marine Gardens.

Extensive alterations took place in 1989 when Bev Robbins installed a tower brewery on site. He revived the name of former owners by calling it the Kemptown Brewery and even adopted the Dolphin brand image of the old company for the new venture. The distinctive mansard roof was fitted at the same time. Sadly, Bev died of cancer in July 2006. His widow, Brenda, sold the pub in 2015 and the brewery is not operating at the time of writing. It was a very successful enterprise during its time and was even claimed to be the smallest commercially-operating tower brewery in the world. The pub is wallpapered with replica copies of newspapers and on the low wall leading to the toilets are two stories featuring Bev himself. The local branch of CAMRA honour his memory by awarding the Bev Robbins trophy for the best Sussex-brewed beer at their festival.

BRISTOL BAR, PASTON PLACE

The Bristol Hotel was built in 1835 by its designer and proprietor William Henry Hallett, who around the same period had established the Bristol Brewery in nearby Seymour Place. The hotel and brewery were named after local landowner and Hallett's patron, the Marquis of Bristol. Rotherfield-born Hallett was too ambitious to be merely architect, surveyor, builder, coal merchant and brewer (as the 1845 directory lists his occupations); he was to become Brighton's (second) mayor, its chief magistrate and one of the twelve aldermen of the town. The Bristol Hotel was an exclusive establishment; listed among its residents in nineteenth century-census returns are army colonels, barristers, an MP and a viscount. In the year of Hallett's death, 1862, a separate Bristol Hotel Shades Bar had opened to the north of the main building at No. 17 Paston Place. In 1906, the ownership of the hotel was conveyed by Hallett's trustees to Col Sir Charles Gervaise Boxall KCB, who died in 1914. In a tale of 'what goes around comes around', Hallett's Bristol Brewery eventually became the Kemp Town Brewery, who repurchased the hotel in 1932 for £22,500. They paid almost as much again for in-house architectural firm, Denman & Son, to convert it into flats and a bar in 1935.

The greater, western part of the hotel became Bristol Court; the dining room and still room along Paston Place provided the site of the new bar. The old shades bar was replaced by entrance gates and a covered yard. Some quality work from this rebuilding survives over eighty years later. The small Public Bar at the north appears intact with its corner counter, dado panelling and Art Deco door at the west. The sea facing Saloon Bar has a replacement bar counter and back fittings and a new floor and ceiling. What was once a covered terrace at the raised area is now fully enclosed. The three-quarter-

Bristol Court and the Bristol Bar.

Open for business.

height wall panelling with the fluted cornice remains from 1935 and both bars retain their original lobby entrances. The building itself is Grade II listed – four storeys with an attic and of four full-height bays each with a three-window range. All but the westernmost bay have a porch, above which is a first-floor balcony. Tuscan columns support two sets of cast-iron railings. Note the KTB monogram of the Kemp Town Brewery at the centrepieces of this ironwork at the lower level.

From Regency to Preston via Dyke Road

The cream houses ran away into the west like a pale Victorian water-colour

Graham Greene

1 Lion and Lobster
2 Royal Sovereign
3 Regency Tavern
4 Quadrant
5 Good Companions
6 Prestonville Arms
7 Chimney House
8 Dyke Pub and Kitchen
9 Crown and Anchor

Our final walk takes us from the western end of the seafront all the way to Preston at the north of the city, and is best attempted in two stages. The first starts in an area known as Regency, named after the development in the early nineteenth century of the elegant series of squares facing the sea. We begin in Sillwood Street at the Lion & Lobster. The grand houses just to the east in nearby Oriental Place and Sillwood Place with their giant Corinthian columns and pilasters were created from 1825 to 1828 by Amon Henry Wilds. Our second pub, the Royal Sovereign, inhabits a Regency building with a late Victorian shades extension. It stands in a street otherwise occupied almost entirely, it seems, by restaurants. All the cuisines of the world would appear to be on offer here. Or third stop, the Regency Tavern, by no means a small building, looks exactly as if it has been squeezed into this tiny passageway. It has an interior that is as camp as camp can be – the Prince Regent would have loved it. Until 1807, neighbouring Regency Square was Belle Vue Field, a place for fairs and other gatherings. On 28 March 1797, a windmill was transported from here in some style, on a sledge pulled by eighty-six yoke of oxen, to near the site of the Dyke Pub, encountered later on this walk. This stage concludes with high-Victoriana at the Quandant pub by the clock tower, the latter built in 1888 and memorably described by Sir Nikolaus Pevsner as 'worthless'.

The second stage starts at Seven Dials, so named for being at the junction of seven roads. It is best approached from the clock tower either by a walk or a bus journey north along Dyke Road. Before setting off, just to note that the North Street Brewery of Smithers once fronted onto what is now the lower part of Dyke Road. We now enter an area of early to mid-Victorian suburban expansion, although the Good Companions, our fifth pub, is a 1939 exercise in the Neo-English Renaissance. Pause first though to admire Montpelier Crescent, 1843–47 by Amon Henry Wilds. It stands roughly on the site of the cricket ground owned by William Lillywhite, also once proprietor of the Royal Sovereign, called at earlier. We make our exit from Seven Dials at Prestonville Road, taking a detour into the area of that name developed as middle-class housing by Daniel Friend. Here we visit the Prestonville Arms, built 1868, and the Chimney House, a pub for the past 120 years but originally two private residences. Tracking back onto Dyke Road, by way of Exeter Street and Port Hall Road, we make our way north to the Tudor-revivalist Dyke Road Pub & Kitchen. Depart from here and cut down Millers Road, named after the earlier mentioned windmill. On Preston Road is our final pub, the Crown & Anchor, 'Established 1711' when Preston was a small village. For those who then want to start another walk or just go home to recuperate, buses back to Brighton depart regularly from the opposite side of the road.

LION & LOBSTER, NO. 24 SILLWOOD STREET

In July 1866, this commodious inn, then called the Olive Branch, hosted an inquest into the suspicious death of Mrs Ellen Warder at No. 36 Bedford Square, the nearby lodgings she had recently taken with her husband, Dr Alfred Warder, a lecturer in poisons and expert in toxicology. Despite the attentions of both her husband and a Dr Taafe, Mrs Warder failed to recover from a sustained bout of vomiting and stomach pains. Dr Taafe had first been called in by Mrs Warder's surgeon brother, Dr Branwell.

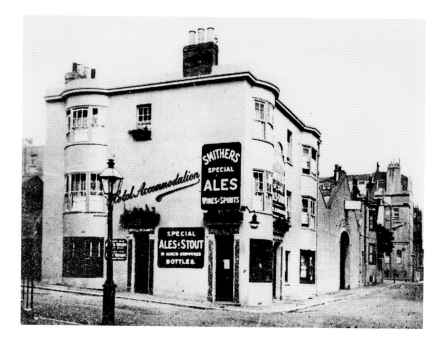

Olive Branch
(courtesy of
the James Gray
Collection).

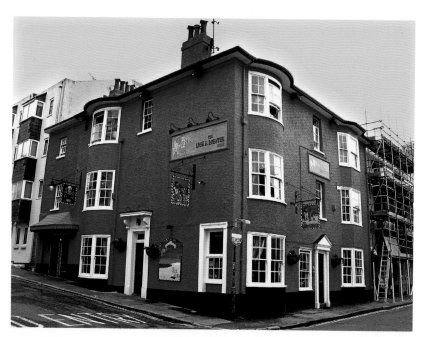

In the pink as
the Lion &
Lobster.

When the brother conveyed his suspicions about the husband to Dr Taafe, the latter refused to sign the death certificate. The inquest was adjourned for six days to allow further medical analysis of the dead woman's stomach contents. It resumed to pass a verdict of murder by aconite poisoning, administered by her husband, by which time

he had committed suicide at the Bedford Hotel by swallowing prussic acid. It later transpired that this had been his third marriage, the previous two wives having met their end in mysterious circumstances.

The Olive Branch opened in 1839 under licensee John Pocock, founder at the same time of the adjoining Bedford Brewery. Both brewery and inn were eventually sold in 1906 to Smithers Brewery, themselves acquired in 1929 by the Kemp Town Brewery who, in turn, passed into the ownership of Charrington. In 1978 the inn underwent a change of name to the Rockingham, which as a free house became a popular gay pub. It was handily situated opposite the Caves club, which stayed open an hour later in the evenings, so there the drinking continued. In 2001 the inn became Whelan's Lion & Lobster when purchased by Dublin-born actor Gary Whelan – well known for his television roles as Detective Inspector Haines in *The Bill* and headmaster Brendan Kearney in *Ballykissangel*. Whelan sold the pub in 2014 to the London-based City Pub Company, who have made no changes to what is best described on its website as 'a rabbit warren of nooks and crannies, crammed with an eclectic collection of bits and pieces'.

ROYAL SOVEREIGN, NO. 66 PRESTON STREET

This probably began life as a private residence, but became a public house in 1823 under licensee Henry Lee. The owner in 1837 was 'The Nonpareil Bowler' Fredrick William Lillywhite, a Sussex County cricketer and proprietor of a nearby cricket ground where Montpelier Crescent now stands. He was a pioneer of round-arm bowling – a transitionary style between underarm and over arm. Lillywhite later moved to London where he helped one of his sons to establish the famous cricket equipment shop that bore the family name.

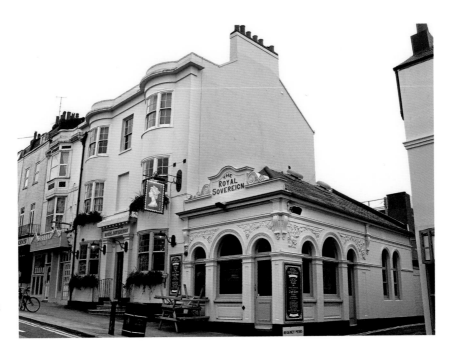

Royal Sovereign, Regency with Victorian wing.

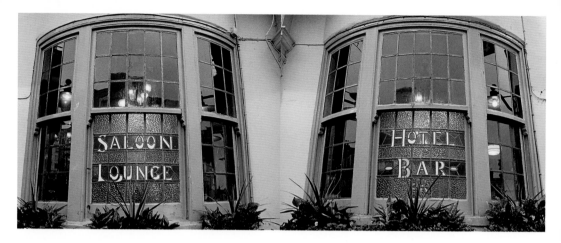

Art nouveau at the Royal Sovereign.

The Royal Sovereign is a Grade II-listed Regency building, three storeys in stucco, double bow fronted with tripartite windows, the first floor central window blind above a classical porch entrance with Doric pilasters. As can be seen from the elegant art nouveau leaded-glass lettering in the ground-floor bow windows, there was once a Hotel Bar (removed 1931) at the front right of the central entrance and a Saloon Lounge at the north side. A Smoking Room used to be located at the centre rear, probably dispensed with during the enlargement of the bar area in 1955.

The low, single-storey extension at the south is from 1886. The pub name appears on a curved pediment flanked by scrolls and carried by a parapet, below which is decorative work on the spandrels. The end door in the round-arched three-bay arcade was converted from a window in 1950 – the same year that this wing became one Public Bar. It had previously consisted of a Billiard Room at the east end, a Private Bar in the centre and a smaller Public Bar at the west. The surviving window on Regency Mews is etched 'The Royal Sovereign Hotel Shades'.

Hotel Shades

By the 1860s, the term Shades Bar is used as a synonym for Wine Vaults and denotes any separate, self-contained drinking bar apportioned to a hotel. It appears to have had an older, most specialised meaning as a downstairs 'dive' bar or one otherwise sheltered in some way from the sun. A story, probably apocryphal, states the term to have originated in Regency Brighton. In 1816, a coal merchant called Mr Edmund Savage had converted an old bank into drinking premises (now the Royal Pavilion Hotel). Directly opposite the back entrance lived the mistress of the Prince of Wales, Mrs Fitzherbert, whose splendid residence, Steine House, was so tall as to block the sunshine from Mr Savage's place. The name Shades he thus adopted for his new venture. In another version of the story, Mrs Fitzherbert had objected to a sign erected at the hotel that referred to spirits as well as wines, gin at this time being a plebeian drink. Shades hence became an inoffensive indication that spirits were sold. If the

Hotel Shades.

connection appears tenuous, consider the further suggestion that the term Shades also signified the availability of prostitutes, being used interchangeably with Oyster Bar, the word oyster being Victorian slang for vagina.

REGENCY TAVERN, NOS 32–34 RUSSELL SQUARE

It is said that this tavern began life in 1836 as a beer house called the Gate, so named because part of the building operated as a toll. It is first identified as the Regency Tavern in 1855 at what was then No. 3 Regency Colonnade, a passageway connecting Regency Square and Russell Square that may once been accessed by such a gate. A beer retailer is listed at that address back to at least 1845. From 1890 to 1902 it was run by the Edlins, who were to become one of Brighton's dynasties of publican families. A new arrival as landlord in 1911 was Percy Foot, who had spent the previous several years as licensee of the Sutherland Arms, Sutherland Road. He died at a local nursing home on 17 March 1926 aged just fifty-one, suffering from oedema of the brain and cirrhosis of the liver. The latter condition in those days was probably something of an occupational hazard, but his widow, Miriam, carried on as landlady and outlived her husband by another thirty-four years.

In 1938 owners Tamplins Brewery purchased the adjoining boot and shoemakers shop at No. 32 and incorporated it into an improved interior to designs by Arthur

Regency Tavern camp (courtesy of Shepherd Neame Brewery).

Regency Tavern camp (courtesy of Shepherd Neame Brewery).

Packham. The early nineteenth-century building is now Grade II listed and consists of three storeys with parapet, original sash windows, decorative stucco panels, pilasters and stepped capitals. The tavern hit the news for all the wrong reasons in July 1990 when landlady Jackie Penfold collapsed behind the bar and later died after the windows were smashed by hooligans venting their frustration at the England football team's exit to Germany in the World Cup semi-final. Happier times arrived with the flamboyant Chris and Geoff, who took the Regency aspect of the name to its full extent and furnished the interior in fabulously camp fashion with gilt-framed mirrors,

chandeliers, brocaded curtains, revolving glitter balls and reflective-tiled gents. All of this the current owners, Kent brewery Shepherd Neame, have wisely retained in a pub that is a microcosm of the Royal Pavilion, Brighton, at its outrageous best.

The Landlords

The Edlins became the most powerful family of publicans in Brighton. Henry William Edlin from the Shadwell area of London married Shropshire-born Emily Sarah Jones. They held the Talfourd Arms, Camberwell in 1881 and three years later were in Brighton at the Black Lion Inn, Gloucester Road. Henry spent two years at the Regency Tavern, dying there aged just forty-two on 2 March 1892. Emily carried on the license until 1902. Their four sons, Fredrick William (1878–1947), Harry Smith (1882–1959), Walter John (1883–1932) and Lloyd Edgar (1886–1971), all became licensees, but Harry also pursued a career as the comedy film actor and music hall artiste, Tubby Edlin. The family formed a limited company and owned several pubs and hotels in the town, most notably the Great Globe in Edward Street, the Gloucester Hotel in Gloucester Place, Mortons Hotel in Queen's Road, the Northern Hotel in York Place and, featured in this book, their headquarters, the King & Queen in Marlborough Place. Emily died on 22 May 1938, her age recorded as ninety-one, although her census returns consistently suggest a birth year of 1854. As a measure of the family's success, her eldest son Fredrick left effects worth £101,000 on his death– over £3.5 million in today's money.

QUADRANT, NOS 12–13 NORTH STREET QUADRANT

Occupying a landmark position opposite the clock tower, North Street Quadrant was erected in 1851, with numbers 12 and 13 becoming conjoined as the Quadrant Hotel in 1863–64. A Grade II-listed building of four storeys in stucco with a parapet, the ground floor has grey granite pilasters carrying a fascia cornice with TOM BOVEY, WINE & SPIRIT IMPORTER signage. This is of genuine Victorian vintage but uncovered as recently as 2007. Tom Bovey was the new landlord of 1899 who had the pub refaced and refitted that year to a design by Robert W. Pollard. The work must have been expensive and was certainly intended to make a statement about Bovey's arrival, socially speaking, as a successful man.

The lower bar at the south end retains many original fittings with moulded ceiling, brick and wood surround fireplace and panelled semi-circular chunky counter. Across the central circular servery is a highly ornate arched gantry with pediment, mirrors, scrollwork, fluted Ionic columns and bowed entablatures (a partition originally ran from the counter at this point to separate this Saloon Bar from the bars at the north end.) At the rear exit to Air Street is a bowed staircase screen with a pair of engraved glass panels, one a replacement. In the flat-arched porch entrance on Queen's Road, the curved window at the right has the faint outline of letting once applied to the glass:

<div align="center">

The Quadrant

Saloon Lounge

Choice Wines and Spirits

BASS' PALE

</div>

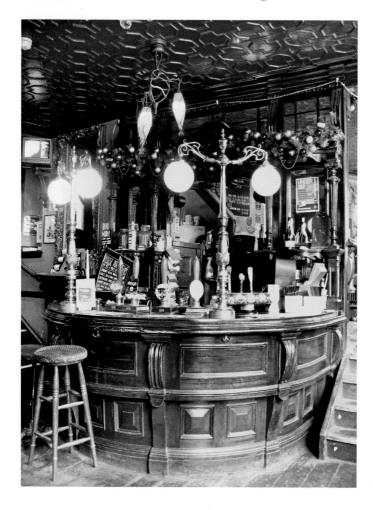

Tom Bovey's bar of 1899 at the Quadrant.

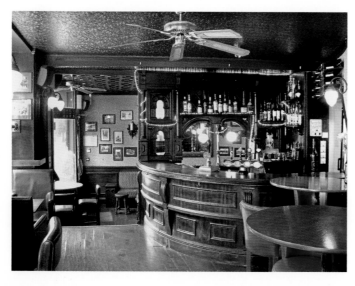

Upper bar at the Quadrant.

The top level of the pub used to be the Public Bar, entered though the existing corner doors. The counter here is a 1960s facsimile. From the apex of the original ran a partition dividing this area from a Private Bar at the north-west, some of the space this occupied now hidden behind the internal wall of the servery. Walk around the outside into Air Street to see its former door and window, since converted to a stairwell. The Quadrant closed for a period of time when this whole block of buildings was redeveloped. Saved by its Grade II listing of 1999, it was subsequently reopened by its current operating company Drink In Brighton. It has since been designated a CAMRA pub of regional heritage importance.

The Landlords

The seventh child of a master painter, Tom Bovey was born in Torquay, Devon in 1860. Tom married into an established family of Brighton publicans when he and Carry Pitt were wed at St Michael's, Brighton on 12 March 1885. Carrie was the sister of Robert William Pitt, landlord of the Evening Star in Surrey Street, the Cricketers in Black Lion Street and proprietor of the Lion Hotel in St James's Street. Tom became landlord of the Thatched House in Black Lion Street by 1887. He spent 1892–93 at the nearby Sea House in Middle Street before moving to the Eight Bells in West Street. In 1899 Tom and Carrie took the Quadrant and had it refitted in glorious high-Victorian style. That year they had a daughter, Doris Lillian. Their son, Thomas Ashcroft, was born in 1890. Tom Bovey died aged sixty-five on 23 September 1925. Carrie continued to hold the license of the Quadrant until her death, aged seventy-three, in June 1938.

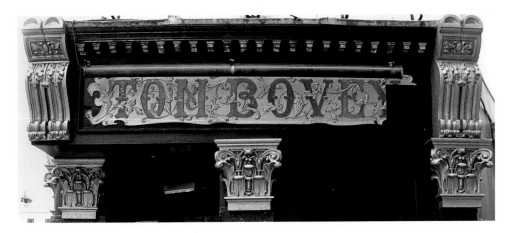

Tom Bovey signage at the Quadrant.

GOOD COMPANIONS, NO. 132 DYKE ROAD

This pub is reputed to have opened on Sunday 3 September 1939, the day that Britain declared war on Germany. The building was certainly completed that year – check out the rear wall rainwater pipe head – and the license was acquired by Tamplins brewery on 2 August by special removal from another of their Brighton pubs, the Thatched House. A large private residence, Chichester Lodge, occupied this spot until demolished

Left: Good Companions, built 1939.

Below: Bar counter at the Good Companions.

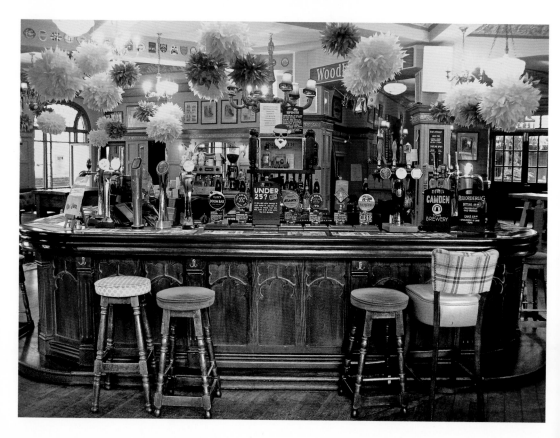

in 1937. Tamplins Brewery purchased the site in May 1938 and January 1939 for £3,350 and secured the building contract in December 1938 at a cost of £8,986. The tall and imposing two-storey building with its steeply pitched tiled roof harks back to the late seventeenth-century English Renaissance, almost certainly to a design by Arthur Packham. The main entrance would have been through the now disused corner door under the prominent chimney stack and provided access into separate rooms: note another disused door down the left side. This area has picture-height wall panelling and a fine art nouveau fireplace in polished granite. The attractive island counter has art nouveau panels between fluted pilasters. The extent to which these articles are original or imported is unclear but the Courage Brewery exterior signage dates from the 1960s. The pub is now operated by Indigo Leisure and was placed in 2015 on Brighton and Hove City Council's Local List of Heritage Assets.

PRESTONVILLE ARMS, NO. 64 HAMILTON ROAD

This corner site pub dates from 1866, the first property to be built in Hamilton Road. Its first landlord, Richard Cave, remained here until 12 January 1879 when he died from pneumonia, aged forty-three, having suffered for three years from chronic bronchitis. His widow Mary carried on the licence until 1888. A framed copy of his death certificate is displayed inside the pub. Nearby is a photograph of a wedding party – spot the tired cake on the trestle table. To judge by the clothes it is around the 1940s and is taking place outside the pub's corner entrance that then led to the Public Bar. Two other entrances have each been replaced by a hinged, drop-down window.

The former entrance in Bridgen Street gave access to both a Bottle & Jug and another Public Bar; the fireplace of the latter still remains, the raised area behind used to be a lock-up shop. The other entrance was in Hamilton Road and to the Saloon Bar, as can still be seen from the name in the old etched glass. The bar area beyond

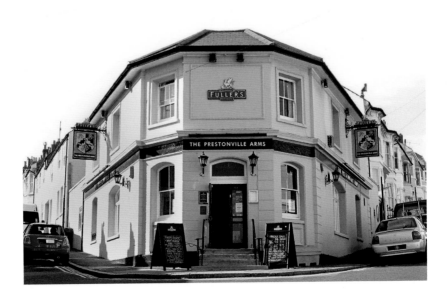

The symmetrical Prestonville Arms.

Brighton backdrop for the Prestonville Arms.

has brought into use what had once been a living room. An etched Smoking Room window of late Victorian vintage now hangs over the fireplace. The old room divisions are marked by the arrangement of roof beams and jutting walls. Until the 1950s this was a Kemp Town Brewery house, later acquired by Charrington. It is now owned by Fuller's who in 2006 obtained it from Gale's. Landlord Andy White has been here for sixteen years and is a recipient of the brewery's Master Cellerman Award.

CHIMNEY HOUSE, NO. 28 UPPER HAMILTON ROAD

This attractively detailed red-brick building was built in the mid-1880s as two separate residences at Nos 65 and 66 Exeter Street, the former occupied by George Pratt, Coachman (the coach entrance survives to this day), and the latter a private house. These became combined in 1896 as the Marquess of Exeter, the name by which the pub was known until recently. The Coat of Arms of the Marquess appears in decorative plasterwork on the gable surmounting the projecting bay of each elevation. Herbert George Welsh became landlord in 1906 and two years later his daughter Marjory was born at the pub. In those days it was not allowed to open on Sunday due to some clause in a will that continued until the death of the last surviving family member (presumably connected to the last occupant of it as a private residence). The Welsh family left in 1916 but returned four years later to remain until 1934, with Marjory now working behind the bar at what was then a Kemp Town Brewery house.

Three disused doors, each marked by the lozenge in the top pane of glass, show the west side of the pub to have once consisted of small rooms. There was also a smoking room with a quarter-sized billiard table, and a piano on which Marjory would practice during quiet periods. She was once asked by an elderly gentleman to play him a

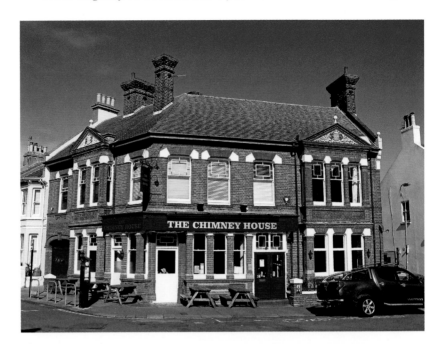

Chimney House, originally the Marquess of Exeter.

Manager Charlie behind the bar at the Chimney House.

selection of his late wife's compositions, which she did so from the sheet music he provided. It was clearly a 'last request' for sadly a few days later his body was washed up on the beach. The pub today boasts a fine old mahogany bar back with mirrors, fluted pilasters and scallop inlay. Whether it and the matching counter are *in situ* or

imported articles is unclear, but it provides a perfect backdrop for the photograph of manager Charlie Brookman. It is also a handy repository for the book of Marjory's recollections, published in 1999 shortly after her death. The pub, now operated by Punch Taverns, was placed in 2015 on Brighton and Hove City Council's Local List of Heritage Assets.

DYKE ROAD PUB & KITCHEN, NO. 148 DYKE ROAD

Above: Windmill Inn of James Trusler (courtesy of the James Gray Collection).

Left: Neo-Tudor Dyke Road Pub & Kitchen.

Until recently known as the Dyke Road Inn (formerly Hotel) this is a splendid 1895 Tudor revivalist pub with half timbered gabled bays and stone mullioned and transomed windows. It replaced a crude stone building called the Windmill Inn, originally owned by James Trusler who in 1866 purchased the nearby Preston Mill at the top of what is now called Millers Road. It was outside the old inn, at 12.30 p.m. on Saturday 9 July 1887 that PC Standing apprehended William Walton. Early that morning Walton had murdered his wife Sarah at the family home off St James's Street. He had cut her throat to the bone and fractured her skull with a hammer. James Trusler was succeeded at the Windmill Inn in 1879 by his nephew William M. Trusler who continued as licensee until 1905, the last thirteen years as a tenant, for the freehold premises were purchased by Tamplins Brewery for £4,200 at the Auction Market, Brighton, on 12 December 1892.

The plans by C. H. Buckman for the present building are dated 1893 and labelled 'proposed rebuilding of the Windmill Inn,' indicating that naming the pub after Dyke Road was an afterthought. A new central lobby entrance was installed in 1932, originally giving access to, left, a Private Bar, and right, a new Saloon Bar, created from conjoining the 1895 Bar Parlour and Coffee Room. The dining room at the rear was also a 1932 addition. A Public Bar at the north-west corner was accessed both from its projecting bay and from a door along Highcroft Villas. Beyond was a Tap Room, now marked by the internal arch over. The pub was recently refurbished for its present owners but the sanded down linenfold counter with fluted ionic pilasters and matching half-height oak panelling may have been incorporated from the original design. It was placed in 2015 on Brighton and Hove City Council's Local List of Heritage Assets.

CROWN & ANCHOR, NO. 213 PRESTON ROAD

Scene of many an inquest: Crown & Anchor Inn.

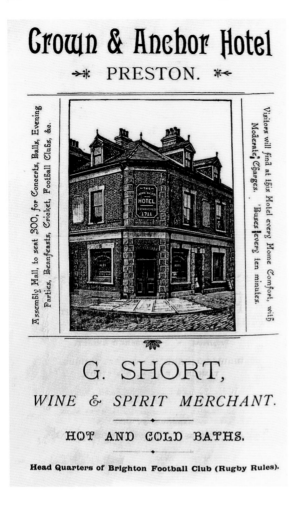

Crown & Anchor Hotel
PRESTON.

Assembly Hall, to seat 300, for Concerts, Balls, Evening Parties, Beanfeasts, Cricket, Football Clubs, &c.

Visitors will find at this Hotel every Home Comfort, with Moderate Charges. 'Buses every ten minutes.

G. SHORT,
WINE & SPIRIT MERCHANT.

HOT AND COLD BATHS.

Head Quarters of Brighton Football Club (Rugby Rules).

Hot and Cold Baths (Towner's Directory of 1904).

Established by 1711, this was once an inn of some importance as a coaching stop on the main London Road. On Sunday 14 August 1831 it hosted the inquest into the death of Celia Holloway. The jury returned a verdict of wilful murder against her husband, John Holloway. His lover and possible accomplice, Ann Kennett, was remanded for further questioning. The case against Holloway was compelling. Celia was killed and dismembered at a house in the North Steine. The accused couple then transported pieces of her in a wheelbarrow to a copse in Lovers Walk, not far from the Crown & Anchor, and buried them in a shallow grave. Holloway was hanged at Horsham Gaol on Friday 21 December 1831; Kennett was subsequently discharged. The recovered parts of Celia were interred at nearby St John's church, Preston. The spot is marked on the churchyard wall by a plaque that graphically refers to the 'deposited portions of her remains'.

Plans of 1887 by C. Nye for Smithers Brewery show a rebuilding of the old inn in half-timbered style. The frontage was altered to its present form in 1898. By 1904, the hotel, as it had become, was the headquarters of the Brighton Rugby Football

Club, who played their matches on Preston Park. Mr George Short, licensee for thirty years, provided the clubrooms and changing facilities. These had presumably been converted from the billiard room shown on Nye's 1887 plans as a low, single-storey rear extension. This subsequently became a gymnasium and the hotel a prestigious centre for boxing, attracting famous figures such as Tommy Farr, Terry Downs and Don Cockel. The gym has long been demolished and modern housing and offices now stand on the site, but old photographs of boxers are displayed in the conservatory extension. This large pub used to have three bars: note two disused doors, one at the front centre, the other along the south wall; interior chequer floor tiles mark the site of the latter.

Bibliography

PRIMARY SOURCES AT THE KEEP, FALMER, EAST SUSSEX

Building Alterations, ACC 5611/3 and DB/D/7 and 8
Brighton Borough Petty Sessional Division Licensing Plans, PTS/2/9
Brighton Pubs, by H E S Simmons, Vol. 1-12, BTNRP BH600156
Deeds of Courage Public Houses, AMS5681
Golden Cross Inn, AMS6610/9
Queen's Park Tavern and Cricket Ground, HOW/55/29
Registers of Licences, PTS/2/6
Sussex Biographies PAC to PAN, BTNRP BH500398
Tamplins Licensed Properties Ltd, Estates Ledger, TAM 2/8/1

SECONDARY SOURCES

Antram, Nicholas and Morrice, Richard, *Brighton and Hove: Pevsner Architectural Guides* (New Haven & London: Yale University Press, 2008)
Batchelor, Marjory, *A Life Behind Bars* (Brighton: QueenSpark, 1999)
Beard, John, *Brighton & Hove Pubs Past and Present* (Hove: J B Enterprise, 1998)
Berry, Sue, *Georgian Brighton* (Chichester: Phillimore, 2005)
Bishop, John George, *A Peep into the Past: Brighton in the Olden Time, with Glances at the Present* (Brighton: J G Bishop, Herald Office, 1892)
Chapman, Brigid, *East Sussex Inns* (Newbury: Countryside Books, 1988)
Collis, Rose, *Brighton Boozers: A History of the City's Pub Culture*, (Brighton: Royal Pavilion, Libraries & Museums, Brighton & Hove City Council, 2005).
Collis, Rose, *The New Encyclopaedia of Brighton* (Brighton: Brighton & Hove Libraries, Brighton & Hove City Council, 2010)
Collis, Rose, *Death and the City: The Nation's Experience, Told Through Brighton's History*, (Brighton: Hanover Press, 2013)
Dale, Antony, *Brighton Town and Brighton People* (Chichester: Phillimore, 1976)
Dale, Antony, *The Theatre Royal Brighton* (Stocksfield: Oriel Press, 1980)
Dale, Antony, *Fashionable Brighton 1820-1860* (Stocksfield: Oriel Press, 1987)
d'Enno, Douglas, *Foul Deeds & Suspicious Deaths Around Brighton* (Barnsley: Wharncliffe Books, 2005)

Dennis, Peter, Mannall, Beccie and Pointing, Linda, *Daring Hearts: Lesbian and Gay Lives of 50s and 60s Brighton* (Brighton: QueenSpark, 1992)

Eddleston, John J., *Murderous Sussex: The Executed of the Twentieth Century* (Derby: Breedon Books, 1997)

Erredge, John Ackerson, *History of Brighthelmstone* (Forest Row: Brambletye Books, 2005)

Fines, Ken, *A History of Brighton & Hove* (Chichester: Phillimore, 2002)

Flower, Raymond, *The Old Ship: A Prospect of Brighton* (London: Croom Helm, 1986)

Greene, Graham, *Travels With My Aunt* (London: The Bodley Head, 1959)

Gutzke, David W., *Pubs & Progressives: Reinventing the Public House in England 1896-1960* (DeKalb, IL: Northern Illinois University Press, 2006)

Harrison, Frederick and North, James Sharp, *Old Brighton, Old Preston, Old Hove* (Hassocks: Flare Books, 1974)

Holter, Graham, *Sussex Breweries* (Seaford: SB Publications, 2001)

Kemp Town Brewery, *In and Around Brighton: 'Houses' of Repute in Sussex* (Cheltenham: Ed. J. Burrow & Co., n. d., probably 1932)

Preston Village Millennium Project, *Preston: Downland Village to Brighton Suburb* (Brighton: Brighton Books Publishing, 2004)

Maisel, Miriam, By their pubs you shall know them, *A Monthly Bulletin*, Vol. 33, No. 12, pp. 180–187 (December 1962)

Miller, Edwin P., *St James's Street, Brighton, and its Environs: A Walk Through its History from 1800-1910* (Lewes: Pomegranate Press, 2011)

Moore, James, *Murder at the Inn: A History of Crimes in Britain's Pubs and Hotels* (Stroud: The History Press, 2015)

Musgrave, Clifford, *Life in Brighton: From the Earliest Times to the Present* (Rochester: Rochester Press, 1981)

Peskett, Mr. and Browne, G. Miss. (eds.), *The Sketch Club Magazine, 1930-1931* (Brighton: Municipal School of Art, Brighton, 1931)

Rackham, John, *Brighton Ghosts, Hove Hauntings* (Brighton: Latimer Publications, 2001)

Richardson, Nigel, *Breakfast in Brighton: Adventures on the Edge of Britain* (London: Indigo, 2000)

Rowland, David, *War in the City, Volume 1* (Telscombe Cliffs: Finsbury Publishing, 2002)

Rowland, David, *Target Brighton* (Telscombe Cliffs: Finsbury Publishing, 2008)

Thirkell, John, *Top Pubs in the South* (London: Imprint, 1976)

Walkerley, Rodney L., *Sussex Pubs* (London: Batsford, 1966)

WEBSITES

Ancestry, http://www.ancestry.co.uk/

Brighton and Hove Council, Local List of Heritage Assets, http://www.brighton-hove.gov.uk/content/planning/heritage/local-list-heritage-assets

Brighton History, http://www.brightonhistory.org.uk

British Newspaper Archive, http://www.britishnewspaperarchive.co.uk

Historic England, http://list.historicengland.org.uk

My Brighton and Hove, http://www.mybrightonandhove.org.uk

MyHouseMyStreet, http://www.myhousemystreet.org.uk

North Laine Community Association, http://www.nlcaonline.org.uk

The Regency Society, The James Gray Collection, http://regencysociety-jamesgray.com

Acknowledgements

The author and publisher would like to thank the following people for their permission to use copyright material in this book. Dr Alexandra Loske and Sarah Gibbins for the photographs from the James Gray Collection; Eddie Gershon and Gill Evans of J D Wetherspoon for the photographs of the Post & Telegraph; Kathyrn Tye and John Humphreys of Shepherd Neame Brewery for the photographs of the Regency Tavern; the North Laine Community Association for the postcard of Peggy the Trickster Dog; Victoria Homewood for her illustration of the Hand in Hand. Thanks also go to Jackie Dinnis for first putting the author onto the death of Mary Fullick; to the very helpful staff at The Keep, Falmer; and to The University of Chichester for funding the trips to The Keep. Every attempt has been made to seek permission for copyright material used in this book. If copyright material has however been used inadvertently without permission then we apologise and will make the necessary correction at the first opportunity.